IMAGES
of America

AROUND
WORTHINGTON

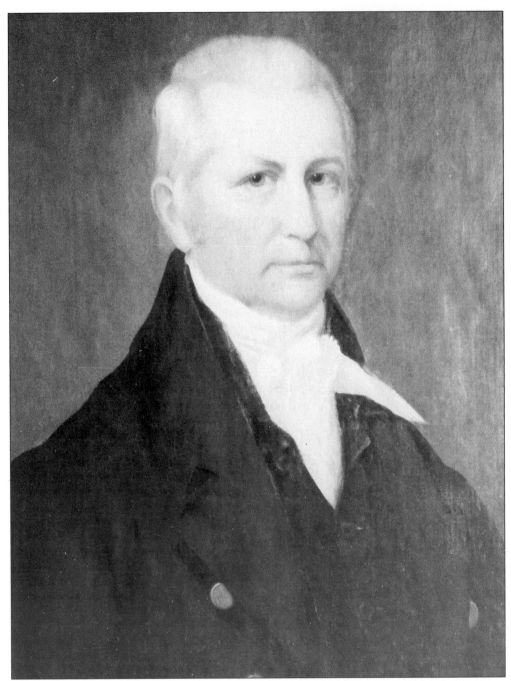

James Kilbourn, a Connecticut businessman and an Episcopal deacon, organized the Scioto Company that founded Worthington in 1803. Kilbourn had an entrepreneurial spirit and was a charismatic leader. He was a visionary, but lacked the confidence to delegate responsibilities and attempted to handle everything himself. Although he founded Worthington and several other Ohio towns, his mismanagement of resources resulted in an unfortunate financial loss for himself and others. He spelled his last name "Kilbourn" until very late in life when he changed the spelling to "Kilbourne." (VEM.)

IMAGES
of America

AROUND
WORTHINGTON

Robert W. McCormick

ARCADIA

Published by Arcadia Publishing,
an imprint of Tempus Publishing, Inc.
2 Cumberland Street
Charleston, SC 29401

Printed in Great Britain.

Library of Congress Catalog Card Number: 99-61272

For all general information contact Arcadia Publishing at:
Telephone 843-853-2070
Fax 843-853-0044
E-Mail arcadia@charleston.net

For customer service and orders:
Toll-Free 1-888-313-BOOK

Visit us on the internet at http://www.arcadiaimages.com

CONTENTS

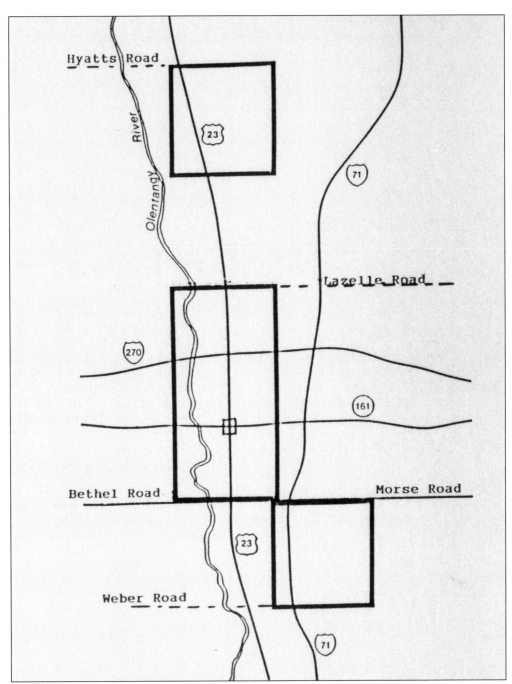

The Scioto Company purchased 16,000 acres of land for $1.25 per acre. This purchase included four parcels of 4,000 acres each. The 8,000 acres that surrounded the village were divided into "town lots" and "farm lots" and were considered by these New Englanders to be the "town" of Worthington. This tract was really the western half of Sharon Township. The other two parcels were primarily investment purchases; few of the original 38 proprietors settled on these tracts, choosing instead to settle on the 8,000-acre middle tract and sell their portion of the outlying tracts. (VEM.)

6

INTRODUCTION

In 1802 a group of Connecticut and Massachusetts families led by James Kilbourn formed the Scioto Company and purchased 16,000 acres of land in the U.S. Military Tract for $1.25 per acre. The town they planned had a public square at the center of the village and contained 164 lots, plus two lots each for a school and for an Episcopal church. In addition, 100 acres of land each was provided to support the school and church. The original proprietors were to receive town lots and farm lots in proportion to the number of shares each had purchased in the Scioto Company. All of these plans were developed prior to the time the pioneers left New England.

Arriving in Ohio during 1803 and 1804, the pioneer families became the nucleus of a new town that retained its New England flavor in the Ohio wilderness. The town was named for Thomas Worthington, one of Ohio's first senators and later a governor of Ohio, who had assisted James Kilbourn in locating this tract of land.

Worthington became a booming business and manufacturing center before and after the War of 1812. Although Worthington prospered at first, progress slowed as setbacks prevented the community from living up to its early promise. The depression of 1819, unsuccessful attempts to be named Ohio's capital, failure to become a county seat, and being bypassed by the canal and National Road, all contributed to Worthington's status as a sleepy, market village for the surrounding farms during the latter part of the nineteenth century.

In 1893, when an electric street railway connected Worthington with Columbus, the focus of this village changed from a market town to a suburb of a major city. But over half a century was required before this sleepy village acquired the appropriate infrastructure and matured into an attractive suburb. The population of the village of Worthington in 1840 was 440; in 1900 it was 455; and in 1950 it was 2,128. The period from 1950 to 1970 saw Worthington increase in population, become a city, and expand the school district. The construction of an "outerbelt" around Columbus placed a limitation on the growth of the city of Worthington, but did not restrict the growth of the Worthington School District.

Today the Worthington School District has 12 elementary schools, four middle schools, two senior high schools, and one alternative high school. Less than one-third of the 55,000 population comprising the Worthington School District lives in the city of Worthington, with the remainder residing in the city of Columbus or unincorporated areas. Regardless of the geographic location, it is conventional to refer to all of the school district as "Worthington."

This visual history of the landscape and lifestyles around Worthington reflects the development of the area from a pioneer village to a suburb in the metropolitan area of

Columbus. Tracing the changes is especially significant at this time, since the Worthington area will celebrate its bicentennial in 2003 at the same time Ohio celebrates its 200 years of statehood.

The images used to tell the story of the history of Worthington are currently held by a number of public and private sources. The Worthington Historical Society (WHS), with Ms. Jennifer Lane Maier (director), Jane Trucksis (curator), and William Newman (president), contributed a significant number of images, as well as financing the reproduction of the images.

The city of Worthington (CW) contributed photographs, and assistance was provided by Janice McNeel Yarrington, Jeff Soiu, and Ronald Slane. Photographs were obtained from the Library of Congress (LC), National Archives (NA), the U.S. Department of the Interior, National Park Service, Saint Gaudens Historic Site, and Cornish, N.H. (NPS). Also the Worthington City Schools (WCS), Worthington Public Library (WPL), the Metropolitan Park District of Columbus and Franklin County (MP), and the Sharon Township Firefighters Association (STFA) provided photographs that were very helpful in telling this story.

Private businesses and industrial firms, as well as public service organizations provided useful photographs for this publication. Included were Anheuser Busch Company, Inc. (ABC), Harding Hospital (HH), Insley Printing Company (IPC), Worthington Area Chamber of Commerce (WACC), Godman Guild Archives (GG), Leasure-Blackston American Legion Post #239 (ALP), Pontifical College Josephinum (PJ), Worthington Arts Council (WAC), and the Worthington VFW Post 2398 (VFW).

Several individuals in the Worthington area contributed useful photographs. In this category were Mary Edge Armstrong (MEA), Candice Brooks (CB), John Butterfield (JB), Thomas Conrad (TC), Wayne and Wanieta Dipner (WWD), Hugh and Sheila Flaherty (HSF), David Foust (DF), Bette Norris Grace (BNG), Charles Lee (CL), Richard Long (RL), Robert W. McCormick (RWM), Virginia E. McCormick (VEM), the late Mary Ellen Minton (MEM), Dwight Moody (DM), Philip Sheridan (PS), Martha Wakefield (MW), Paul Wherry (PW), and Harry Zimmerman (HZ).

The source of each image is acknowledged in the parentheses at the end of each picture caption. The initials following the names above have been used for identification.

The author wishes to dedicate this book and the benefits derived therefrom to the Worthington Historical Society, a nonprofit organization dedicated to preserving the history of the area.

A special thanks is extended to my wife, Jennie, for her devoted assistance with the preparation of this book.

—Robert W. McCormick

One

NINETEENTH-CENTURY LIFE

Nineteenth-century life in Worthington began with a very real, but very short frontier period, which extended from the time of the first settlement to the conclusion of the War of 1812. The pioneer lifestyle passed very quickly and was followed by a short period of rapid growth and booming business opportunities.

The depression of 1819 wiped out the promising business opportunities, and the area around Worthington remained an agriculturally based economy, with the village of Worthington serving as a market town. While the Civil War had a significant impact on the lives of the residents through the military and war-related service of sons and husbands, the area continued to depend largely on its agricultural orientation during the post-war era.

The final decade of the nineteenth century brought the first signs of Worthington's transformation into a suburb of Columbus with the arrival of the street railway. At the dawn of the twentieth century, the population of Worthington was the same as it had been 60 years earlier. The village had been stirred from its sleepy state, but was not fully awake.

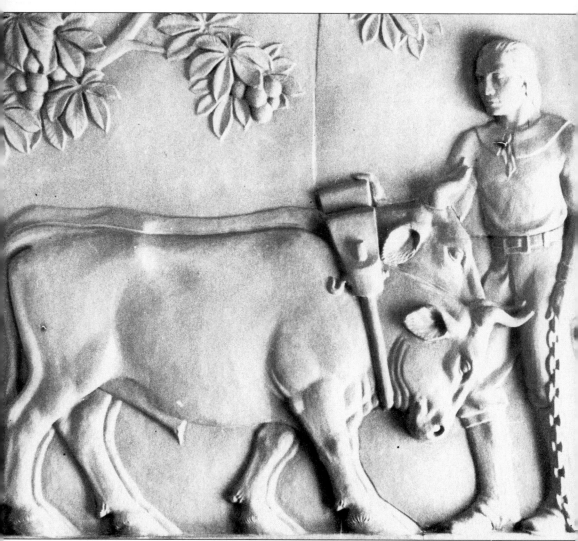

The Scioto Company Settler is a terra-cotta relief created by Dayton, Ohio artist Vernon T. Carlock for the Worthington post office in 1938 as part of the New Deal's Public Works of Art Project during the Great Depression. This was Worthington's first commission for public art. It features a man with the team of oxen preferred by pioneer settlers for breaking the virgin soil of Ohio—a simple image of the common people who migrated west to settle Worthington—framed by buckeye leaves that symbolize the state of Ohio. (NA.)

This map of the Worthington area drawn by Joel Allen, October 4, 1804, emphasizes the streams, creeks, and rivers, which were the existing "highways" for pioneer settlers in central Ohio. Columbus did not exist at this time, but the settlement of Franklinton, just southwest of the junction of the Scioto and Whetstone Rivers was Worthington's most significant neighbor. (WHS.)

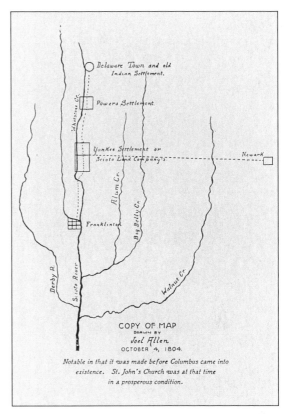

James Kilbourn and Nathaniel Little were sent by the Scioto Company to explore this part of the Northwest Territory in 1802. They left New England by stage coach and traveled across Pennsylvania to Fort Pitt on horseback and by foot. They rowed from Pittsburgh to Wheeling and then hired horses to follow Zane's trace, explored land around "Big Belly" (Big Walnut) Creek, and met Thomas Worthington in Chillicothe. (WHS.)

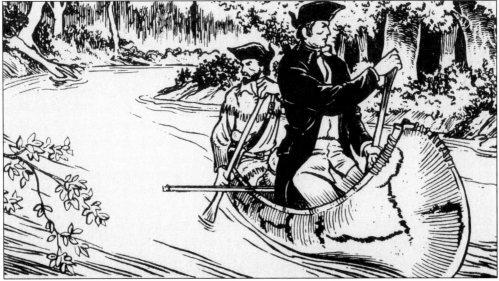

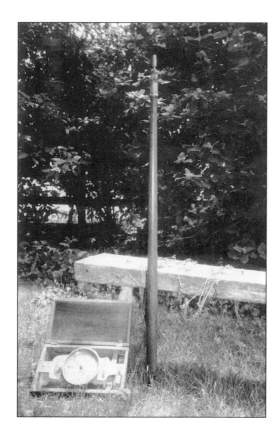

James Kilbourn used the survey chain, sextant, and pole—now owned by the Worthington Historical Society—to survey the town lots in the village of Worthington and the farm lots in the 8,000 acres surrounding the village. The same equipment was later used by Kilbourn when he was appointed the government surveyor for the U.S. Military District in central Ohio. (VEM.)

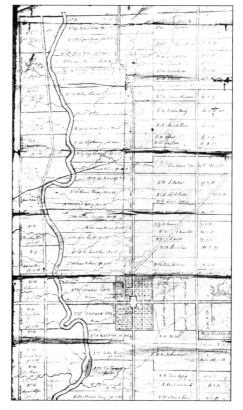

This map showing the farm lots in the 8,000 acres surrounding Worthington was drawn by Kilbourn in 1804 following his survey. The Whetstone River is shown with a proposed road on its west side. The middle road is now High Street, the east-west road is Dublin-Granville Road, a portion of the road on the right remains as Proprietors Road, and the diagonal is Worthington-Galena Road. (WHS.)

The original 164 town lots in Worthington are shown on this map, which was also surveyed and drawn by James Kilbourn. The central block is the Public Square of approximately 5 acres, with 1.5-acre lots on the northeast side for the school and on the southeast for the Episcopal church. The remaining .75-acre "town lots" for residential and commercial use were selected during the bidding by company members in December 1803. North and South, Morning and Evening Streets still bound the "Old Worthington" historic district, but State Street is now Granville Road and Main Street is now High Street. For several decades most homes and businesses were constructed along Main Street, with the business center developing south of the Public Square. (WHS.)

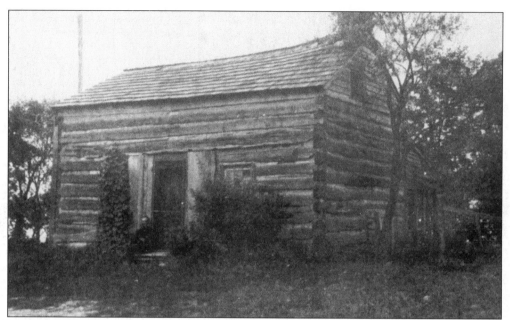

Log homes around the Public Square were built by an advance party during the summer of 1803. These were temporary housing until settlers could select their own lot and build more permanent dwellings. While none of the original Worthington cabins survive, the above photograph is representative of the early log dwellings in and around Worthington. (*Old Northwest Genealogical Quarterly*, January 1904.)

Students drew this mural of the westward migration of the Scioto Company for the Sesquicentennial in 1953. This was more than a decade prior to the establishment of the Worthington Historical Society's annual "Third Grade Week"—a series of educational programs designed to develop an understanding of the pioneer settlers' lives. (WCS.)

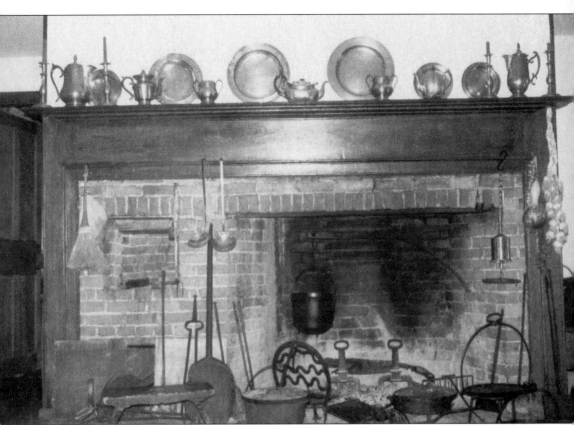

The "keeping room" was the most important part of the dwellings pioneers built as they moved from the temporary log houses to brick or frame homes. Such rooms served the family for cooking, eating, and many of the functions of a "family room" today. This room in the 1811 rear section of the Worthington Historical Society museum at 956 High Street shows the large cooking fireplace. This residence was the first home built by Arora Buttles, a skilled brick mason who erected many of the early brick buildings in Worthington including the Masonic Lodge and St. John's Episcopal Church. (VEM.)

The Public Square served a number of community purposes in the nineteenth century. It was the location for militia "muster days"—often more a social event than military training—, the site for political rallies, and Fourth of July celebrations. It has always been publicly owned and continues to be the site for concerts, celebrations, art shows, and other community functions. (WHS.)

RETURN J. MEIGS, JUN. POST-MASTER GENERAL

OF THE

United States of America,

TO ALL WHO SHALL SEE THESE PRESENTS, GREETING

Know Ye, That confiding in the Integrity, Ability, and Punctuality of Arora Buttles Esqr

I DO APPOINT him a Post-Master, and authorize him to execute the duties of that Office at Worthington, in the County of Franklin, and State of Ohio. according to the Laws of the United States, and such Regulations conformable thereto, as he shall receive from me: TO HOLD the said Office of Post-Master, with all the Powers, Privileges and Emoluments to the same belonging, during the pleasure of the Post-Master General of the United States, for the time being.

In Testimony whereof, I have hereunto set my hand, and caused the Seal of my Office to be affixed, at Washington City, the twenty-ninth day of January. in the year of our Lord one thousand eight hundred and Sixteen. and of the Independence of the United States the fortieth

Registered Febr 15th 1816.

Arora Buttles's appointment as Worthington postmaster in 1816 reflects the influence of his father-in-law, U.S. Congressman James Kilbourn, who secured successive appointments as Columbus postmaster for two other sons-in-law, Matthew Mathews and Joel Buttles. Worthington received its first post office in 1805 with Nathaniel Little serving briefly as the first postmaster, followed by William Robe. (RWM.)

Thomas Worthington, the U.S. land agent in Chillicothe, met James Kilbourn and Nathaniel Little when they explored the Northwest Territory in 1802 for the Scioto Company. Worthington advised them to purchase land that was already privately owned and was for sale for $1.25 per acre rather than the $2-per-acre cost of government land. In appreciation, Kilbourn and the Scioto Company named their town in honor of Worthington. (VEM.)

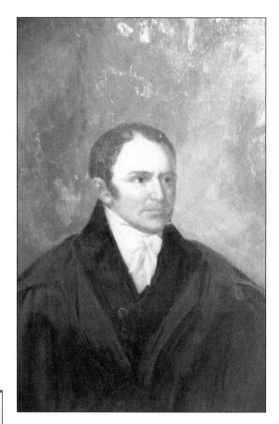

THE WORTHINGTON MANUFAC-
TURING COMPANY

Have just received from New-York,

A LARGE & ALMOST UNIVERSALLY ASSORTED

S T O R E

OF

EUROPEAN AND INDIA

GOODS.

They have also a great variety of ariticles of Domestic Growth and Manufactures, particularly such as are usually received from Kentucky, Tennessee and Pittsburg.----All which they are offering for sale on the lowest terms that can possibly be offered for prompt pay, at their store-house, (late the store of James Kilbourn,) in Worthington.

They also wish to hire a JOB of making RAILS and FENCING done, for which they will give GOODS, at Cash price in payment, if application is made soon.

JAMES KILBOURN, *Agent*
of said Company.

Worthington, March 27, 1812. tf.

The Worthington Manufacturing Company was created by James Kilbourn as a chain of retail stores in central and northern Ohio. Later, the company attracted craftsmen such as weavers, tanners, blacksmiths, and hornsmiths to Worthington to manufacture items needed on the western frontier. The company collapsed during the depression of 1819, and Kilbourn lost his entire investment. (WPL.)

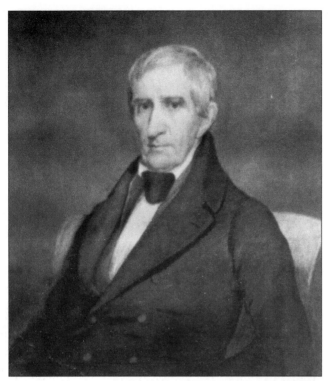

General William Henry Harrison was placed in command of U.S. troops after the defeat of General Hull's militia by the British and Indians at Detroit during the War of 1812. Many of these troops marched through Worthington on their way north, and there is a letter from General Harrison dated October 28, 1812, from "Northwest Army Headquarters in Worthington." (VEM.)

President James Monroe visited Worthington on his tour to inspect the "coastal and frontier fortifications" after the War of 1812. After spending the night at Delaware, the president and his aides rode south to Worthington on August 25, 1817, where he was greeted by Colonel Kilbourn and a crowd of several hundred persons assembled on the Public Square. (WHS.)

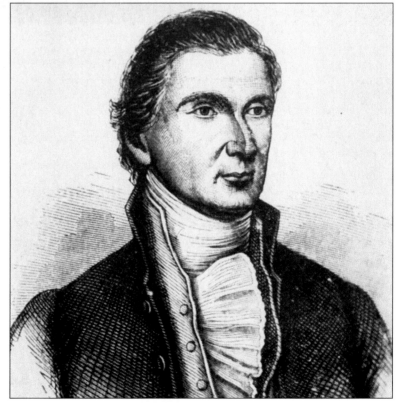

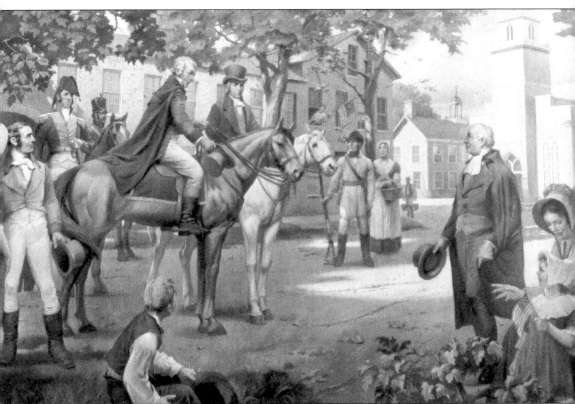

This painting in the Worthington Public Library commemorates President Monroe's visit, but it is an artistic impression that fails to capture the true splendor of the classical celebration that was described in the *Western Intelligencer* and *Columbus Gazette*. A triangular bower had been erected, supported by three columns connected by arches draped with green boughs. Young ladies dressed in white, with their heads adorned with wreaths and garlands, strewed flowers before the president as he ascended this platform. President Monroe addressed the crowd and dined with leading citizens of the community including Colonel Kilbourn and Rev. Philander Chase of St. John's Episcopal Church, who served as chaplain for the day. (VEM.)

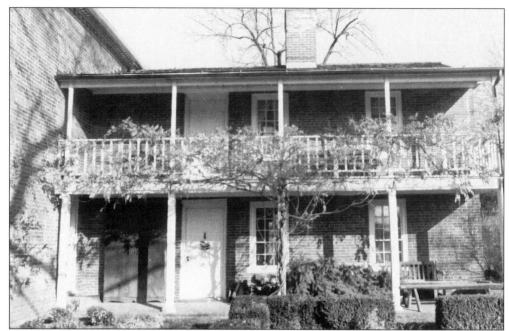

The Buttles house at the rear of 956 High Street reflects the frontier period as the oldest residential structure still standing in Worthington. Arora Buttles built this small brick home in 1811 just before departing with the militia under the command of General Hull during the War of 1812. He had inherited the land from his father; his widowed mother and family lived here during the war. (VEM.)

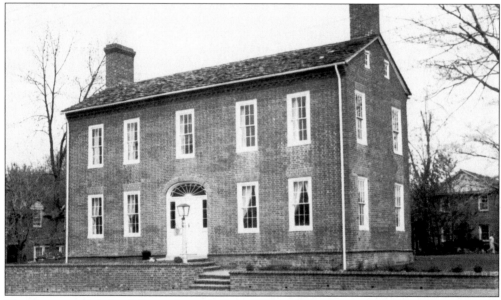

The Orange and Achsa Johnson home built in 1819 with an elegant fanlight entry reflects the affluence of some Worthington residents following the War of 1812. Orange Johnson was a hornsmith and combmaker who came to Worthington to work in the manufacturing company and became a very successful craftsman and businessman. His home is now maintained as a Worthington Historical Society museum. (WHS.)

This view of West State Street, taken about the turn of the century, shows the current Route 161 looking westward from the intersection of Main Street (present High Street) and reveals an era before either of these major roads was paved. For almost two decades it was necessary to ford the stream to cross the Whetstone (Olentangy) River at this point. (TC.)

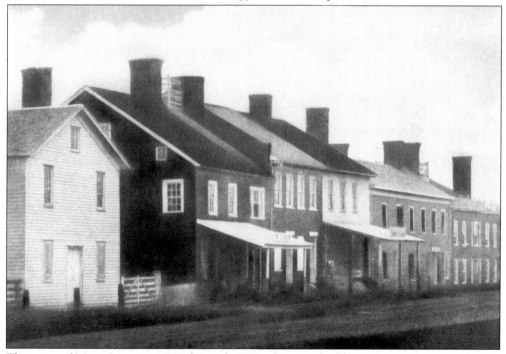

This view of Main Street in 1860 shows that Worthington had become a market town for the surrounding agricultural area. The 1804 home built for the James Kilbourn family at the right was demolished and replaced in 1882, and the replacement was destroyed by fire. His adjacent commercial building built *c.* 1808 is still in use. Three of the six early nineteenth-century structures shown here are still standing. (WHS.)

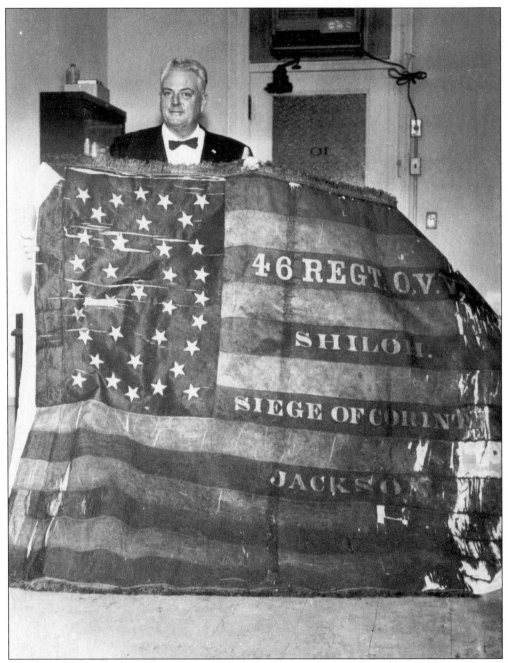

The flag of the 46th Ohio Volunteer Infantry (OVI) commemorates the regiment organized in October 1861 by Col. Thomas Worthington, son of the senator for whom Worthington was named. Only Company "E" of this regiment was recruited primarily from the Worthington area, but the entire regiment mustered at Camp Lyon, which was located at the western end of South Street. It was there that the Worthington Manufacturing Company had functioned in the early nineteenth century. Colonel Worthington was a West Point graduate and had served in the Army during the Mexican War. William Pinney was the highest ranking officer from Worthington, serving as captain of Company "E." (WHS.)

Camp Chase, 4 miles west of the state capitol building, was headquarters for the 46th OVI for a month early in 1862 before the unit was ordered to Paducah, Kentucky. This picture was taken about two years later, but it is interesting to note that the photographer was Manfred Marsden Griswold, grandson of Scioto Company pioneer Ezra Griswold. (NA.)

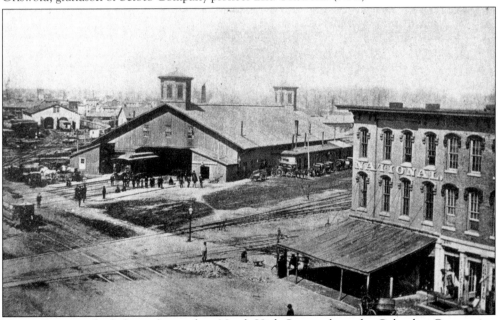

Union Station, which formerly stood on North High Street where the Columbus Convention Center is now located, was a departure point for Union troops from many points of Ohio throughout the Civil War. Worthington businessman Orange Johnson owned this land and sold it at a substantial profit for the station's construction in 1850 when the railroad arrived in Columbus. (NA.)

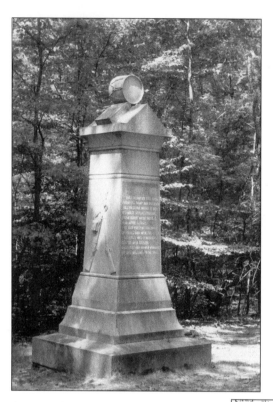

The 46th OVI marker on the Shiloh battlefield commemorates the battle of April 6, 1862, when 34 men from this regiment were killed, 150 were wounded, and 52 were missing. Colonel Worthington was highly critical of the performance of both Generals Sherman and Grant and was subsequently dismissed from the service for his comments. He continued to express his criticism until his death in 1884. (RWM.)

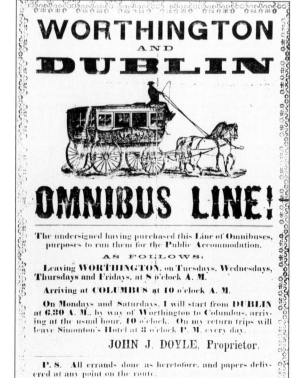

This Worthington-Dublin Omnibus advertisement reveals a two-hour trip between Worthington and Columbus in the post-Civil War period. The primary stop for the omnibus was the current Worthington Inn—called the Bishop House, Central House, and Union Hotel during the latter part of the nineteenth century. Elias Lewis and Miles Pinney of Worthington owned this line prior to John Doyle. (WHS.)

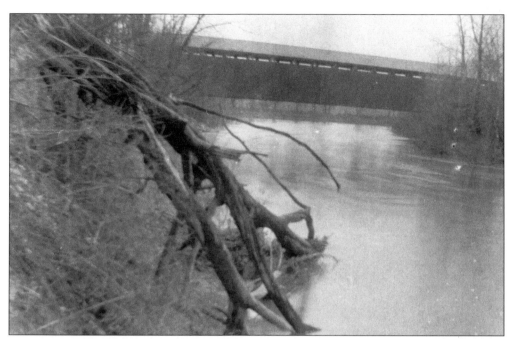

The covered bridge shown here carried Wilson Bridge Road over the Olentangy River. In 1911 the newspaper reported the demise of this structure stating that "the Wilson bridge, which was being repaired, was carried down the Olentangy River when the ice went out." This denied access to the one-room Wilson School built in 1887, and still standing, on the west side of the river. (WHS.)

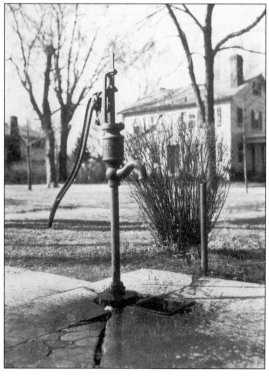

This well on the Public Square was for volunteers fighting local fires and was drilled in the 1890s when the village council appropriated $50 from the fire department fund. A well had, however, been dug on the Public Square shortly after Worthington was settled, and pioneers carried their water from it. In 1868 J.M. Gilbert was paid $17.50 to clean the community well and put in a pump. (IPC.)

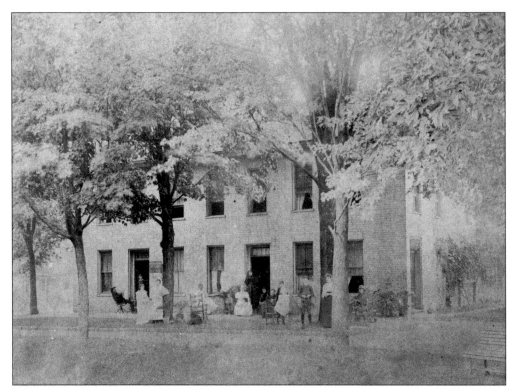

Several members of the Griswold family are seen in this turn-of-the-century photograph of what was then the home of Worthington Franklin Griswold's family of 13 children. For most of the nineteenth century it had been the Griswold Tavern—a popular place for dances, banquets, and liquor consumption by community residents. (TC.)

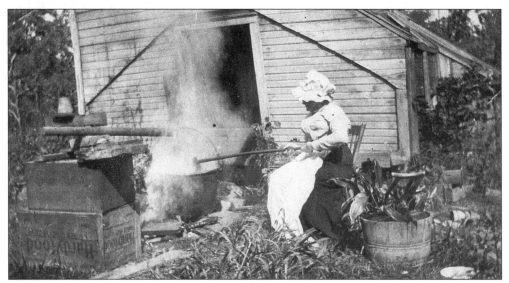

Fondelia, wife of W.F. Griswold, is shown preparing apple butter in this *c.* 1910 picture. She was the mother of the 13 children and was the daughter of Rev. Peter S. Ruth, who had served as rector of St. Paul's Episcopal Church from 1861 to 1863. (WHS.)

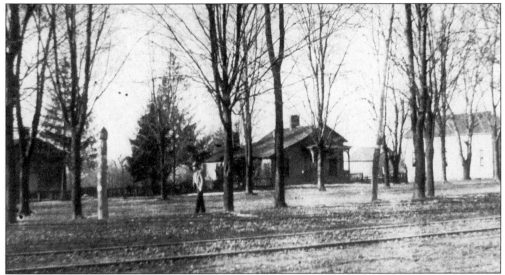

This photograph of the northwest quarter of the Village Green was taken shortly before the turn of the twentieth century. The tracks document that the street railway was functioning between Worthington and Clintonville. The pole standing in front of the man is reported to have served as a signal for the engineer of the street railway. The original Presbyterian church is on the right. (WHS.)

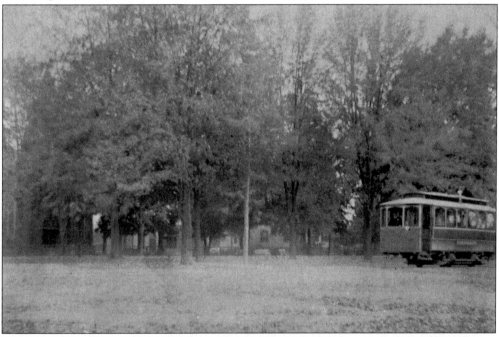

Electric street railway cars arrived from Clintonville and turned around at the Public Square beginning in 1893. The track down the middle of High Street changed Worthington from a market town for the surrounding farmers into a metropolitan suburb. People could now live in Worthington and commute to work in Columbus. A decade later the tracks were extended, offering interurban trains from Columbus through Worthington to Delaware and Marion. (WHS.)

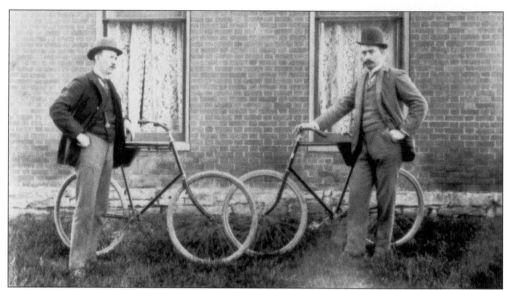

Safety bicycles were the rage by the 1890s. Rufus Weaver (left) and Harry Leasure, pictured in 1898, pose with their prized possessions. The safety bicycle was invented in England in 1876 and quickly replaced cycles with the large front wheels that were difficult to propel and control. Note the Flemish bond brick construction that was preferred for Worthington buildings. (WHS.)

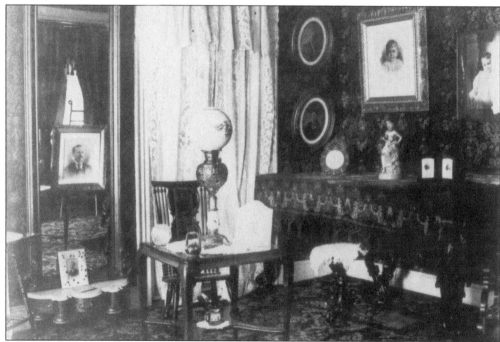

The parlor of the widow Cynthia Weavers's family reflects the Victorian furnishings and accessories popular in Worthington late in the nineteenth century. This 1818 residence at 12 East Stafford was originally the home of Arora and Harriet Kilbourn Buttles, but is now used commercially as the offices of the *Ohio Antique Review* and the Convention and Visitor Bureau of Worthington. (WHS.)

Two

RELIGION AND EDUCATION

Religion and education were priorities of the Scioto Company proprietors in 1803 as they made plans to transplant a New England lifestyle to a town in the newly formed state of Ohio. Two lots in the village of Worthington were set aside for a school and also two lots for the Episcopal church. One hundred acres of farmland were dedicated to support each of these institutions. Each proprietor was required to contribute $2 to support a subscription library.

While James Kilbourn wished to have an Episcopal community, there was soon competition from the Methodist and the Presbyterian members of the community. All three denominations organized congregations in the early nineteenth century, which are still vital today.

From its beginning, Worthington had a subscription school in a log house. This was soon followed by a brick academy, and brief attempts to establish a college, a medical college, and a female seminary. In 1825, the legislature passed an act requiring tax support and regulation of common schools, and by the mid-nineteenth century, there were 12 Sharon Township school subdistricts that divided the tax funds, and each had a one-room school.

The Worthington College was initiated in conjunction with the Worthington Academy, but it was not successful. A college started in Episcopal Bishop Philander Chase's residence soon moved to Gambier, Ohio, and became Kenyon College. Today, the only institution of higher education in the Worthington area is the Pontifical College Josephinum.

The Worthington City School District has expanded so that it not only includes the city of Worthington, but a portion of northwest Columbus, and unincorporated areas of Sharon and Perry Townships. It is the Worthington School District, rather than just the city of Worthington, that provides the identification for the Worthington area today.

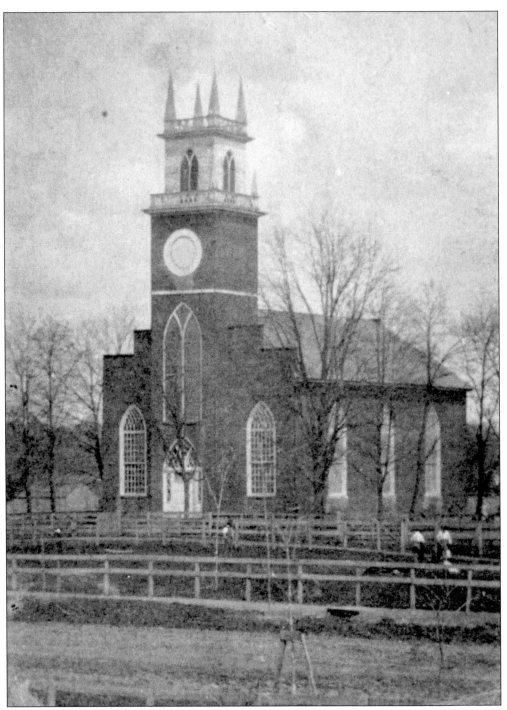

St. John's Episcopal Church was organized on February 6, 1804, the first Episcopal society in Ohio. Early services were conducted in the log schoolhouse on the northeast quadrant of the Public Square and then in the Worthington Academy that replaced it. This building was constructed from 1827 to 1831, and this 1859 photograph shows the original steeple and fence to protect newly planted trees. (WHS.)

The second Methodist church building in Worthington was constructed during the Civil War, to replace an outgrown 1823 building at the corner of Hartford and South Streets. Worthington Methodists trace their origins to an 1808 "class meeting," and the building above has been replaced by a 1926 "third church" and a 1968 "fourth church"—both still in use and each larger than its predecessor. (WHS.)

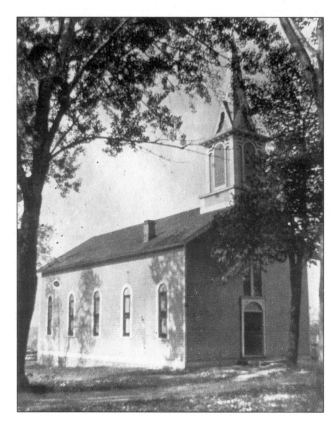

The first Worthington Presbyterian church, built in 1830, was described as "small and plain and looks like a barn," but the addition of a steeple in 1842 created an attractive church. The Presbyterian congregation was organized in 1816 and met in the upper room of the academy, a blacksmith shop, and a one-room school before this church was constructed. (DF.)

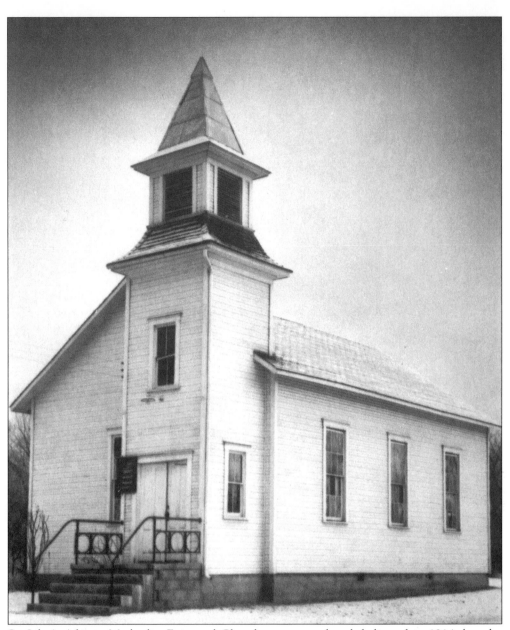

St. John's African Methodist Episcopal Church was erected and dedicated in 1914, but the congregation had been organized in 1897 as the Bethel A.M.E. Church. Meetings were held from house to house among members, but as membership grew, church services and Sunday school classes were held in the town hall until this building was constructed. Free Blacks were part of the Worthington community as early as 1805, and it appears that at least some of them attended the Methodist congregation through much of the nineteenth century, although no record exists of their membership. Worthington minister Rev. Uriah Heath was actively involved in raising funds for the Methodist conference's establishment of Wilberforce University. He also was involved in platting the 1856 Morris addition on the eastern border of Worthington—an addition where African Americans could purchase lots and where the St. John's A.M.E. congregation eventually built its church. (IPC.)

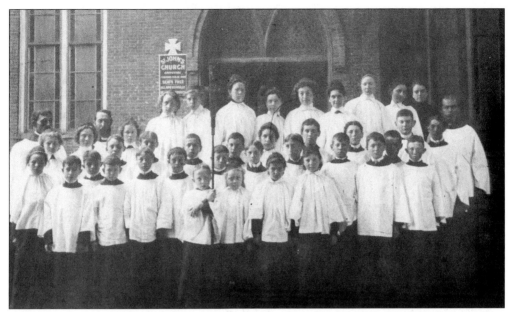

St. John's Episcopal Church choirs—both adult and youth—are shown on the front steps *c.* 1900. By its 1804 articles of agreement, this church was to serve "Worthington and Parts Adjacent"—an area defined to include anyone living within 5 miles of the village of Worthington. (WHS.)

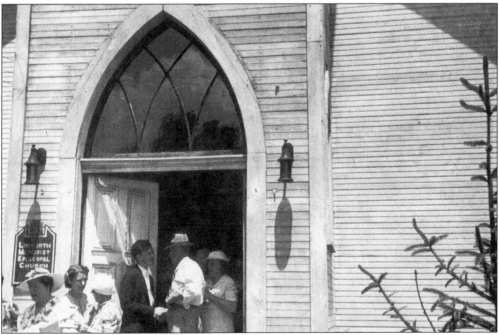

Worshipers leaving Linworth Methodist Church in this 1938 photograph represent a congregation organized in 1886 and a building erected in 1889 that is now used as a bookstore. Originally called Bright's Chapel Methodist Church, it was part of a five-point charge with a total of 332 members. But Elmwood Station—later called Linworth—grew as a station on the Toledo and Central Ohio Railroad. (LC.)

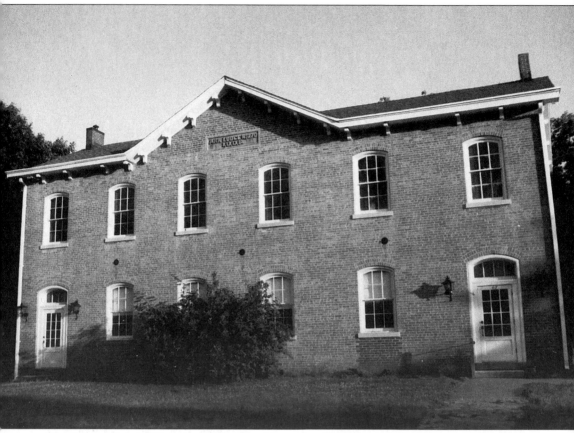

The "Union School" built in 1856 is the oldest school building in Worthington and the first to divide primary and grammar students. There were two classrooms on the ground floor, and since the second story was not immediately needed for classes, it was leased to the I.O.O.F. Lodge (International Order of Odd Fellows). With the construction of a larger school building across the street, which included a high school, this building became the town hall in 1873 serving both the Worthington Village Council and the Sharon Township Trustees. In 1928 the village council moved to a new commercial building at 693 High Street, but this building continued as the township hall until the township trustees moved to the Sharon Memorial Building. In 1975 the Union School was purchased by St. John's Episcopal Church as a facility for meetings and classes. (VEM.)

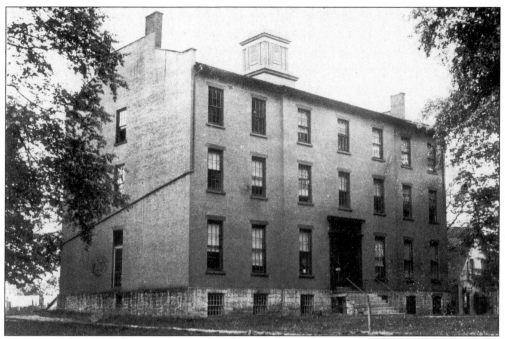

The Worthington Female Seminary dedicated this handsome three-story building in 1842, with classrooms on the ground floor and rooms for boarding students above. This private preparatory school founded by the Methodists in 1839 enrolled a number of students from Worthington and many places across Ohio, and a few—primarily the daughters of Methodist ministers—from other states. (WHS.)

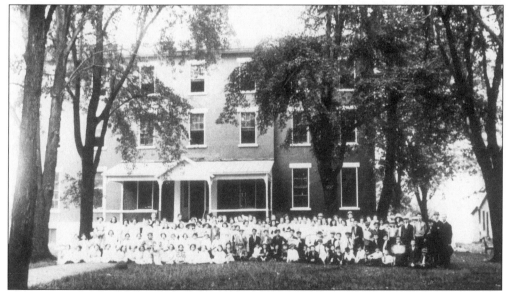

The seminary terminated its activities in 1861, and in 1871 a normal school (teacher training) was opened in the same building. Forty to 50 students boarded in the upper floors and enrolled in elementary, secondary, and administrative courses in teacher education. The Ohio Central Normal School closed in 1881, and the building was then remodeled to become a residential hotel. (WHS.)

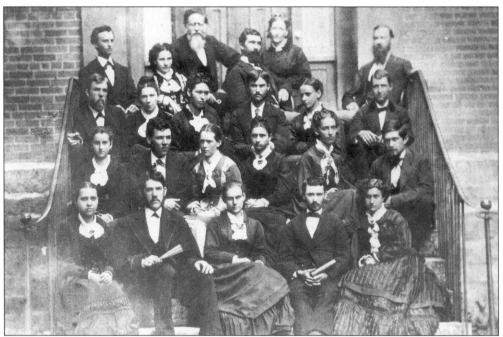

The 1875 graduating class picture for the Ohio Central Normal School includes in the rear Principal John Ogden and his wife, who instituted a special department for training kindergarten teachers. The normal school staff used the Worthington school built in 1874 as a "model school" for training their students—similar to a student teaching experience today. (WHS.)

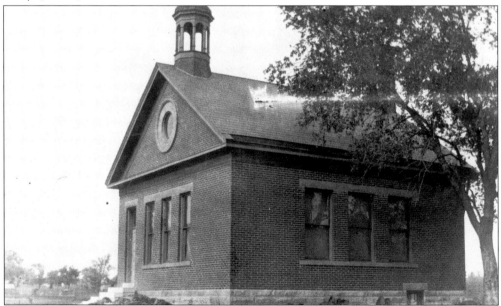

Cherry Hill School is typical of the 12 subdistrict schools—including the village of Worthington—located in Sharon Township during the last half of the nineteenth century. This one-room school on the east side of High Street across from the entrance to Wesley Glen survives today as a dog grooming center. (DF.)

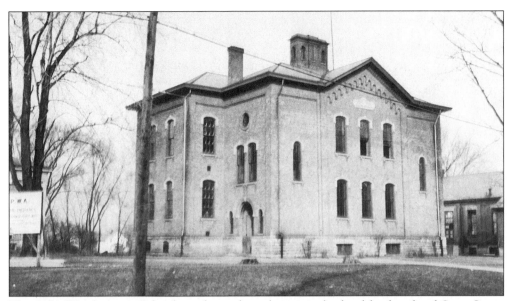

The 1874 Worthington School was located on the original school lot but faced State Street (Granville Road)—replacing the 1808 and 1819 buildings that had served the Worthington Academy, Worthington College, and the Ohio Reformed Medical College. Primary and grammar rooms were on the first floor and Worthington's first high school was on the upper floor of this building. (WHS.)

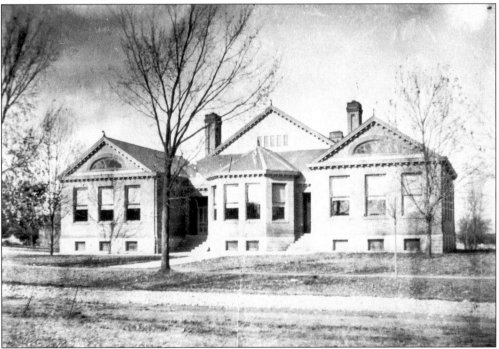

This 1893 school building was the result of increasing enrollments that caused the board of education to purchase adjacent land on East Granville Road and erect a separate high school. It was used for this purpose until 1916 and then as an elementary school until the mid-1930s. (WHS.)

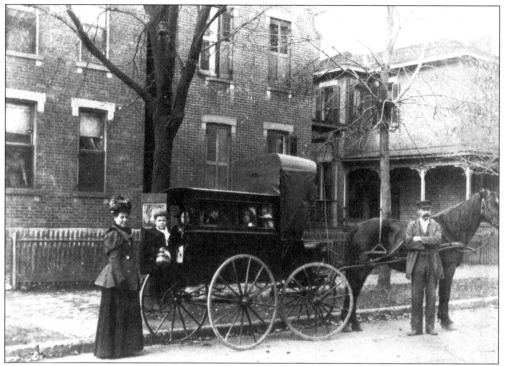

This horse-drawn school bus transported students for Miss Welta Pinney—a Worthington native who operated a well-known kindergarten on Dennison Avenue in Columbus. It is typical of the vehicles used in Worthington and Sharon Township at the turn of the twentieth century as the movement toward school consolidation created a need to transport pupils who lived beyond walking distance. (WHS.)

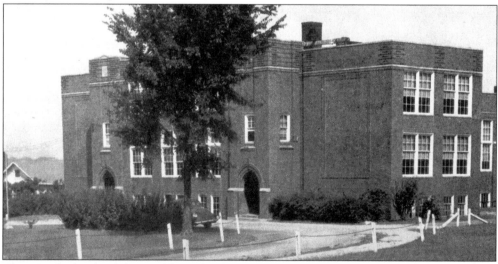

The 1916 high school designed by Columbus architect Frank Packard was built on the school "farm lot" east of the Olentangy River. Vocational and physical education were becoming an important part of the educational curriculum, and this building boasted a "manual training" room, gymnasium, and locker rooms with showers and toilets. The small building on the left in this 1949 photograph was the vocational agriculture shop. (WCS.)

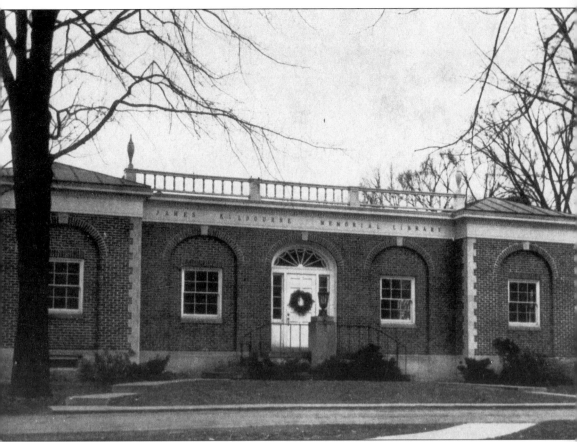

The 1927 Kilbourne Library was erected with a gift from Mrs. William Deshler in honor of her grandparents, James and Cynthia Kilbourne. Although this was Worthington's first library building, Scioto Company members each contributed $2 for a share in the subscription library that became functional when the village was founded in 1803. During the nineteenth century, literary societies had reading rooms at the academy, college, and female seminary; and at the turn of the century volunteers from the local women's club maintained a community reading room. The Kilbourne Library quickly outgrew its original building and north and south wings were added in 1931, as well as a larger addition in 1956. This is now the school district administration building. (WCS.)

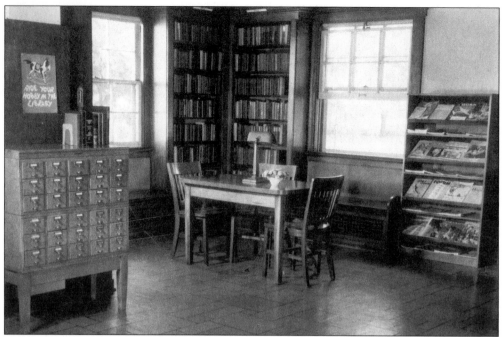

The Worthington Public Library reading room in the 1940s presents a striking contrast with current library activities, which include extensive use of computers, a computerized catalog, video, microform, and compact disk holdings. The "Worthington Room" is a significant addition to the library organization. (WPL.)

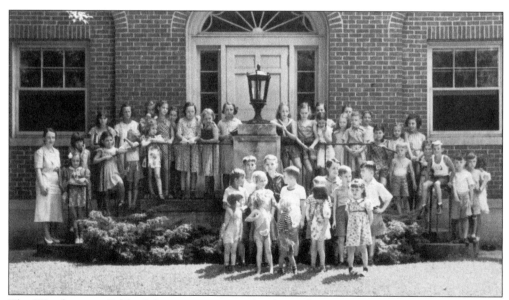

The Worthington Public Library service area has been the same as the Worthington School District ever since 1924. As illustrated by this 1942 photograph, it has been common practice for teachers to take their classes to the library not only for orientation, but also for practice in finding reading and reference materials. (WPL.)

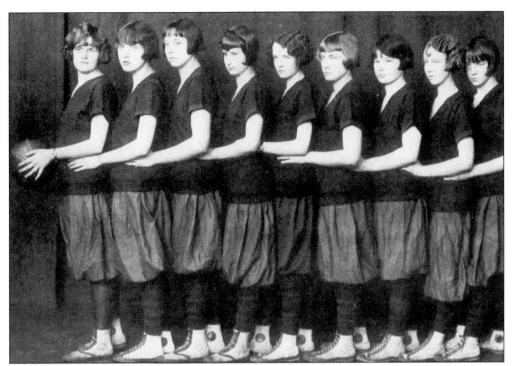

The 1924–25 Worthington High School girls' basketball team won four games out of ten— better than the boys' team—but held high hopes for next year since only one member was graduating. Team members were M. Keys, R. Beard, V. Coffman, C. Hall, M. Schaeffer, I. Dean, and M. Williams, with R. Harding, H. Griswold, and E. Osburn as substitutes. (WCS.)

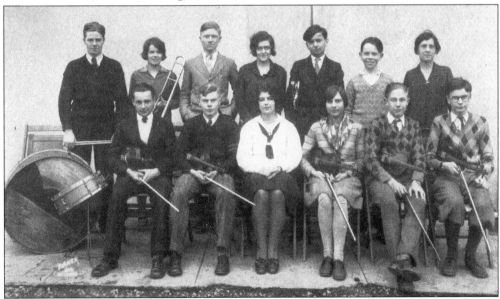

The 1930 Worthington High School orchestra, under the direction of Eloise Sanford, included the following: (front row) Wallace Hard, George Bonnell, Helen Cassidy, Mabel Southard, Alvin Wagner, and Allan Webb; (back row) James Hoskins, Elizabeth Dixon, Jack Slyh, Peggy Scatterday, Junior Hard, and James Michael. (WCS.)

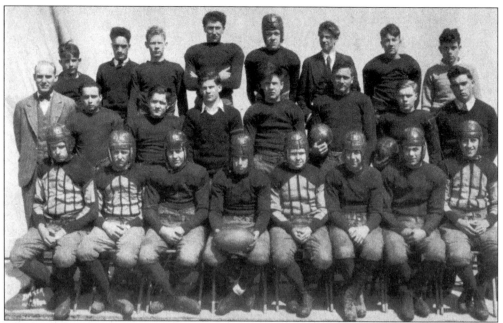

The 1929 Worthington High School football team was coached by Lester Miller and captained by Warren Insley. The team members, from left to right, are as follows: (front row) C. McGuere, L. Alexander, R. Quelette, W. Insley, A.Proudley, R. Knost, B. Gibson, and R. Gibson; (middle row) Coach Miller, W. Hard, A. Anderson, E. Schaeffer, H. Jeffers, E. Trees, G. Bonnell, and D. Anderson; (back row) R. Backus, C. Cook, K. Tice, G. Shupe, L. Long, W. Glave, R. Fenstermaker, and C. Zimmerman. (WCS.)

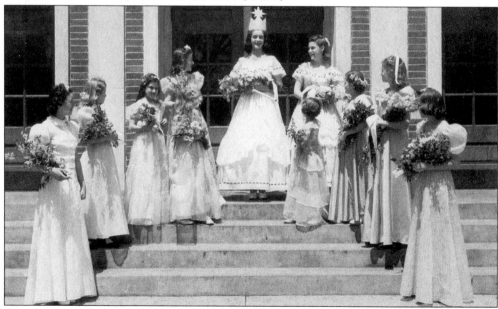

The 1940 May Queen, Janice Snouffer, was attended by Marilyn Ruppersburg, Sally McCord, Barbara Mynatt, Joyce Ann Young, Nancy Fenstermaker, Jane Hoag, Patty Kready, Margaret Hard, Janis Sargent, and Ruth Palmer. The celebration included a May Pole dance by Worthington elementary and junior high school students, and tea was served to guests. (WCS.)

The Worthington High School instrumental music program of 1942 included the school band, an orchestra, and a brass ensemble. As in most high schools, the marching band was a major element of the instrumental music program. (WCS.)

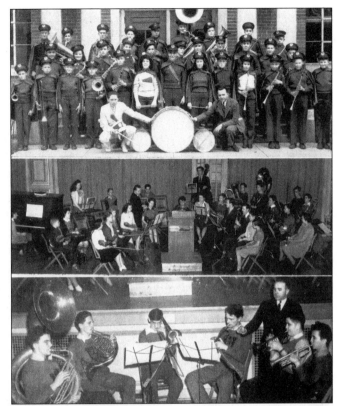

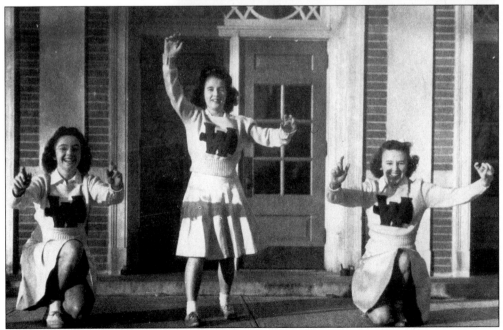

The Worthington High School cheerleaders of 1942 were, as in most other high schools, exclusively female. Together with the marching band they inspired school spirit among the student body to support a variety of varsity sports. (WCS.)

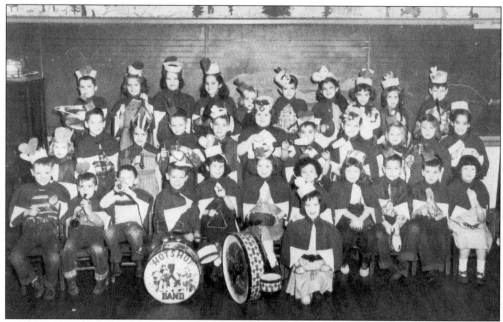

The North Perry School First Grade Toy Band of 1953 illustrates how participation in instrumental music programs began in the early elementary years. This band, from the building on West Granville Road that now serves as the Worthington Alternative High School, appeared on television and was featured in a Columbus newspaper. (WCS.)

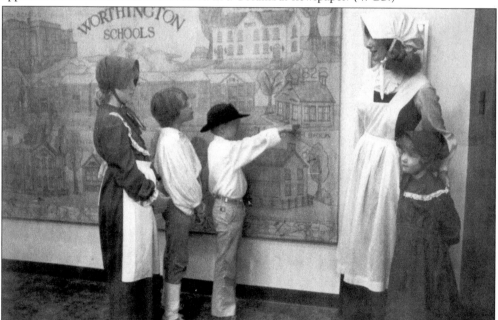

"Third Grade Week" has been sponsored by the Worthington Historical Society since 1965, and some elementary teachers and students don early nineteenth-century costumes as they study the history of early Worthington settlers. The tapestry in this photograph was painted by a Worthington art instructor and portrays all of the Worthington schools prior to the 1952 high school. (MEA.)

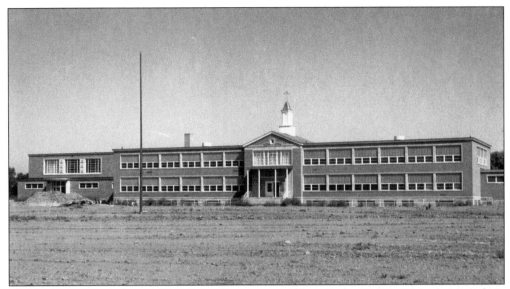

The Thomas Worthington High School campus on West Granville Road has developed for more than 80 years. When enrollments grew rapidly after World War II, the new building shown above was constructed in 1952 to accommodate the growing number of students. Later construction of numerous additions to the building, athletic fields, and a community swimming pool emphasized the wisdom of Worthington's founders in setting aside 80 acres of farmland adjacent to the village to support the school. (WCS.)

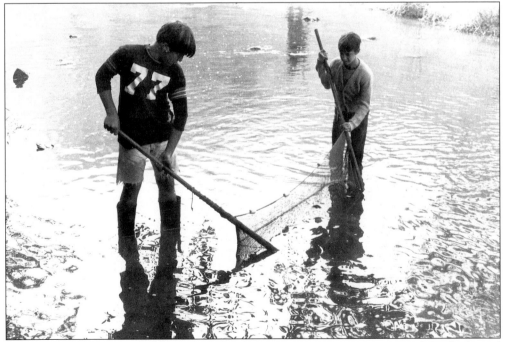

"Stream study" in the nearby Olentangy River became a significant part of the biological science curriculum after the new high school was constructed in 1952. The instructor noted that, "Stream study wouldn't be complete without collecting some specimens and getting wet." (WCS.)

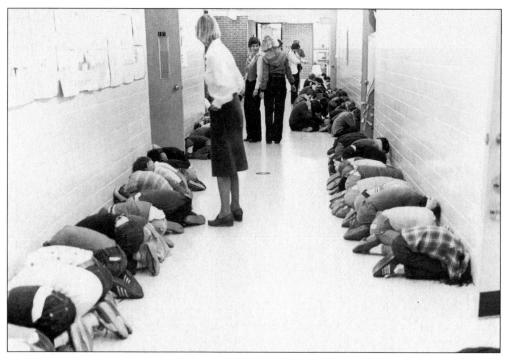

Tornado drills taught these elementary students the procedures they should use for protection in the event of ominous weather such as the typical Ohio spring tornadoes. During the 1950s and 1960s students were also given instructions on the procedures they should use for optimum protection from an atomic bomb attack. (WCS.)

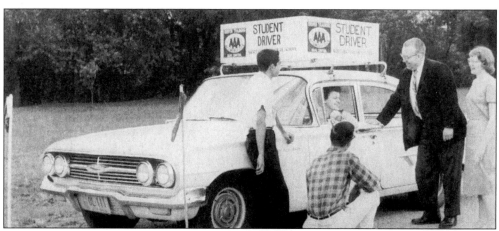

Driver education was part of the high school curriculum in the 1960s, and Ohio required this type of course before any 16 year old could obtain a state driver's license. The curriculum included classroom instruction and outside driving practice. These driving classes were offered both during the school year and during the summer. (WACC.)

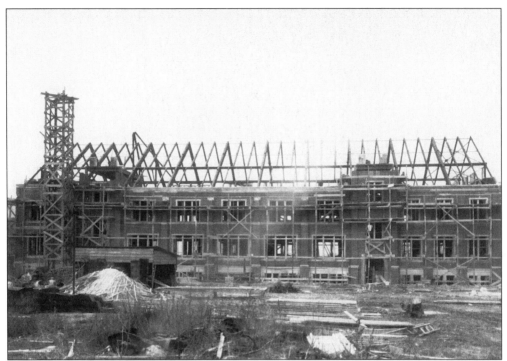

The construction of the Pontifical College Josephinum during 1929–31 provided many jobs during the prelude of the Great Depression. F.A. Ludwig of St. Louis designed the building with its landmark tower, while the general contractor, the Math Roen Company of Chicago, supervised the hundreds of workers. (PJ.)

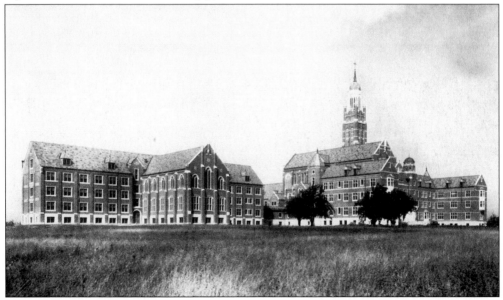

The Pontifical College Josephinum is the only institution of higher education in Worthington. This Catholic liberal arts college and school of theology is the only pontifical seminary in the world outside of Italy. Its $1.5 million building, erected from 1929 to 1931, initially contained more than 300 rooms and was able to accommodate 400 students. (PJ.)

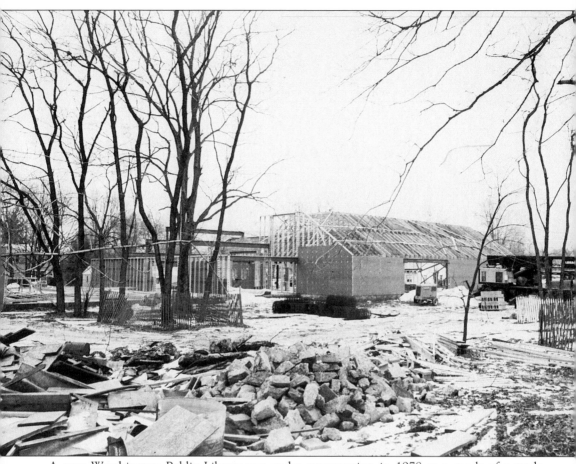

A new Worthington Public Library was under construction in 1978 as a result of a trade between the board of education, which acquired the old library for administrative offices, and the library trustees, who received a building site on Hartford Street. Continuing needs for expansion resulted in a recent addition and remodeling of this "Old Worthington Library" building and construction of a new library in the northwestern part of the school district. This new library is operated cooperatively with Columbus, since homes in this part of the Worthington School District are in the city of Columbus. The renovated 1978 building now includes a community meeting room, a Worthington reference room, an expanded children's area, and vastly expanded computer access facilities. (CB.)

Three
PRIVATE ENTERPRISE

The production of food and fiber products through farming was certainly the predominant private enterprise of the settlers in early Worthington as in any other frontier settlement. But the New Englanders brought with them other skills; these farmers also worked as coopers, blacksmiths, carpenters, cabinetmakers, bricklayers, and in many other trades. Taverns, general stores, and inns were also opened very early in the settlement of Worthington.

The development of the Worthington Manufacturing Company by James Kilbourn and others was a valiant effort to make Worthington a manufacturing and retail center on the western frontier. Kilbourn's background as a weaver in New England made it logical that the company's first objective was to manufacture various kinds of woolen cloth. Subsequent mention is given to leather, ironwork, and pot and pearl ash. During the period immediately following the War of 1812, Worthington attracted many persons with manufacturing and retail marketing skills, but the depression of 1819 literally wiped out the Worthington Manufacturing Company and many of those with manufacturing skills left the area.

During the last 80 years of the nineteenth century and the first 60 years of the twentieth, Worthington moved gradually from a sleepy market town for farmers to a suburb for the city of Columbus. The construction of the Anheuser Busch brewing plant, the development of businesses and warehouses along Huntley Road, the construction of office parks near I-270, the development of the Worthington Mall and other retail areas, and the development of motels and food service areas have brought a substantial increase in non-agricultural private enterprise to Worthington.

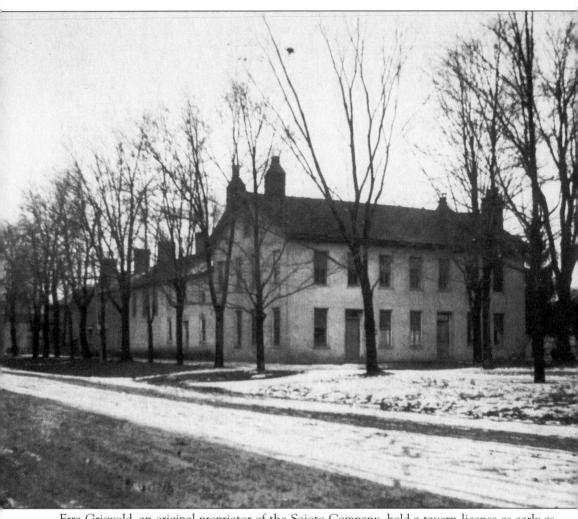

Ezra Griswold, an original proprietor of the Scioto Company, held a tavern license as early as 1807 and erected this large brick building on the northeastern corner of the Public Square in 1811. In addition to accommodating boarders and travelers, many of the community activities of early Worthington—dances and banquets—were held here. Local persons used the tavern for "business entertaining." Ezra Griswold was one of the most prosperous and influential citizens in the Worthington community when he transferred property to his heirs before his death in 1822. The tavern was transferred to his son, George H. Griswold, who not only followed in his father's steps in business, but also as a justice of the peace and as a militia officer. (WPL.)

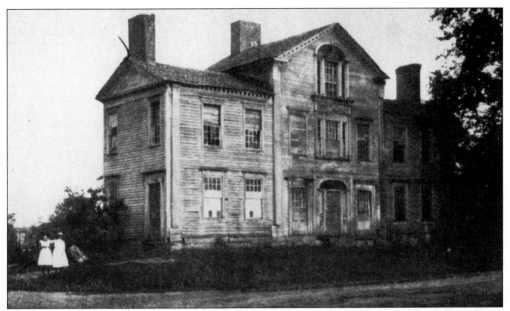

Built prior to 1819, this commodious structure had several owners, but is best known as "Beers Tavern." Architecturally, this was the most distinctive building in the village with a three-story central section and elegantly crafted palladian-style entry. Before it burned down, this building stood on Main Street (current High Street) where the Old Worthington Library's administrative offices now stand. (WHS.)

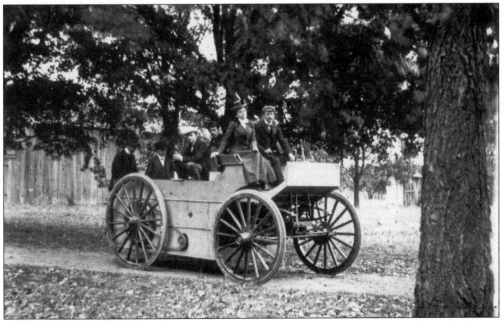

Howard L. Griswold, son of Worthington Franklin Griswold and great grandson of pioneer settler Ezra Griswold, completed correspondence courses in electrical and mechanical engineering in 1899 from the International Correspondence Schools, Scranton, Pennsylvania. The automobile shown above was built by him for the president of the Columbus Railway and Power Company in the early 1900s. (WHS.)

An important event in Worthington was the arrival of a railroad line a mile east of the village in 1851. This means of transportation caused a modest increase in development on the eastern side of the village during the latter part of the nineteenth century and limited transportation between the railroad station and the center of the village. (IPC.)

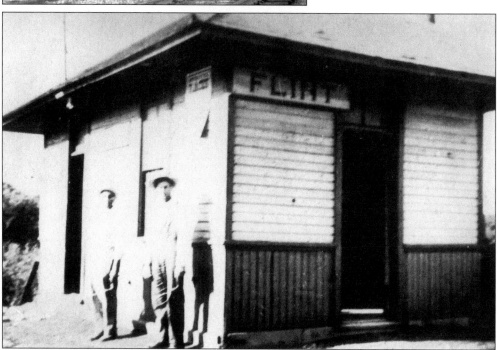

This modest building was the Flint Depot on the North Central Railroad where Flint Road crosses the track in the northern part of Sharon Township. In the latter part of the nineteenth century, the Flint station also served the Westerville community prior to the time that railroad service was extended to Westerville. (IPC.)

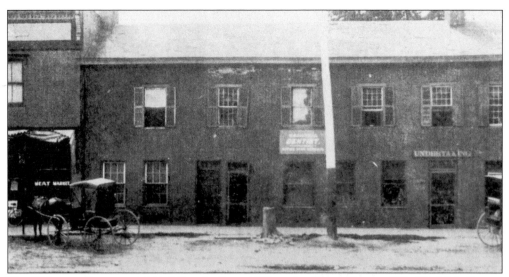

The Kilbourn Commercial Building, built *c.* 1808 and still standing at 679–681 High Street, has been continuously used as a commercial structure to the present time. It originally housed the *Western Intelligencer*, the first newspaper in central Ohio and a retail store. This image, taken before 1904, shows the Frank Goble funeral parlor and the office of W.M. Gantz, dentist. (WHS.)

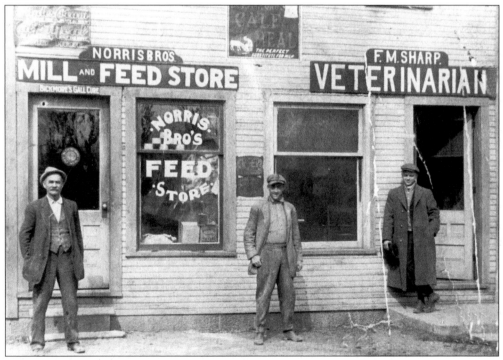

Even in the early twentieth century, the village of Worthington continued to serve as a market town for the farmers in the surrounding area. The Norris Brothers Feed Mill and Store was built in 1907 at the southwest corner of the Public Square and has now been replaced by the Wesley Court condominiums. The persons, from left to right, are Isaac Norris, Clarence Norris, and Dr. Fred Sharp, veterinarian. (WHS.)

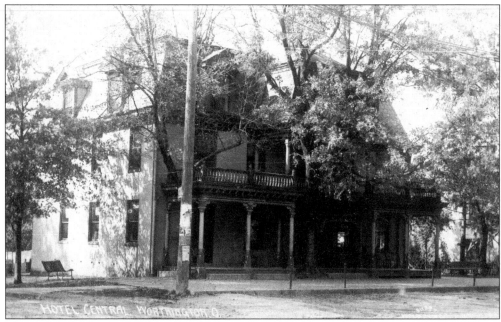

This image shows the Hotel Central (now the Worthington Inn) after the fire-damaged upper story had been replaced in 1902. The owners, George and Nellie Van Loon, rebuilt the inn with a third-floor ballroom topped by a mansard roof and a porch supporting the balcony. The oldest portion of this property is the northeast section that appeared on tax record in 1835. (TC.)

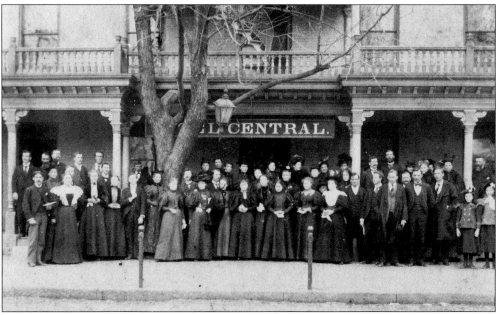

This is another view of the Hotel Central illustrating the hotel being used for group functions in the early twentieth century. This building was originally a residence for the R.W. and Laura Kilbourn Cowles family. After Cowles's death, the building was sold in 1854 to William Bishop, who was the first to operate it as an inn. (TC.)

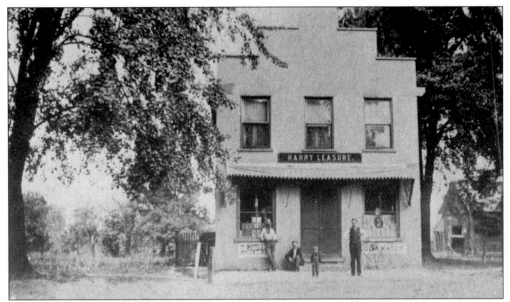

Harry Leasure operated this drugstore from 1894 until 1908. John Snow built this structure *c.* 1834 as a combination store and dwelling, which still stands at 633–635 High Street. The Snow family owned this building until 1916. Leasure had a drugstore at other Worthington locations until his death in 1939. (WHS.)

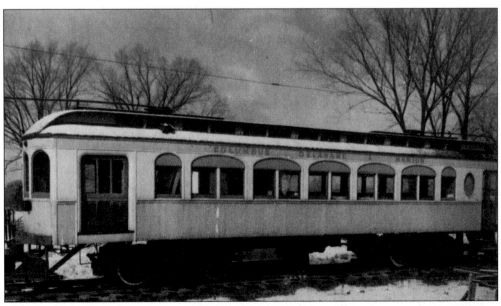

The electric street railway from Worthington to Clintonville constructed in 1893 was converted to an interurban line called the Columbus, Delaware, and Marion Railway (CD & M) in 1902. The car shown here actually saw service on this line and is currently preserved at the Ohio Railway Museum located on Proprietor's Road in Worthington. (WPL.)

Mr. Frame Brown, who had attended Yale University, was given this farm 3 miles north of Worthington when he married a great-great granddaughter of James Kilbourn. From 1910 until his death in 1937 he developed a 150-acre orchard that produced 50,000 bushels of fruit in a good year. His daughter continued to live on and manage the farm until 1958, and she eventually sold it in 1980. (MP.)

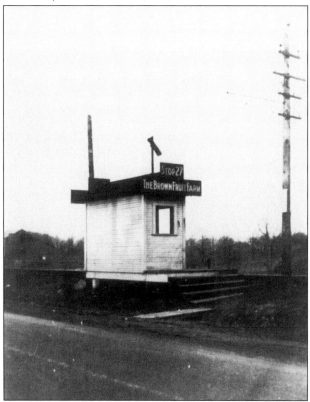

The Columbus, Delaware, and Marion interurban stop for the Brown Fruit Farm was on the east side of present Rt. 23. In the 1920s the road was an unpaved mud track and it was much quicker for farm employees to travel the interurban to and from Columbus rather than to drive a Model T Ford. (MP.)

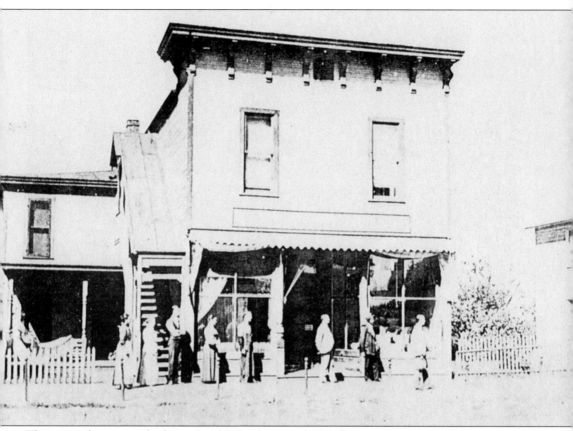

This general store was built in 1890 by Frank W. Bishop, who continued to own the property; the store, however, was jointly operated by Bishop and Worthington C. Lewis. In the late 1890s this became the Lewis Department Store. Lewis is the person standing directly in front of the doorway. This was an active department store in Worthington that employed up to a dozen persons at the turn of the twentieth century. The second floor of this building had a meeting hall with a full stage, which was used for dramatic presentations. This building was a Kroger Grocery Store in the 1920s and is currently the "Nuts and Bolts" section of a hardware store. (MEM.)

This Columbus Pottery building, located on 13 acres of land on the eastern terminus of the Chaseland subdivision south of Worthington, measured 450 by 100 feet. It contained six large potter's kilns and two decorating kilns. In November 1906, half of the main building was destroyed by fire and 200 employees were thrown out of work. In 1914, the Brunt Tile and Porcelain Company began operations and subsequently added new kilns, offices, and warehouses. The property changed hands several times and ceased operation in 1925. The Chaseland subdivision did not enjoy the rapid growth anticipated by its developers, since the adjacent pottery plant was a negative rather than a positive influence on the residential development. (WHS.)

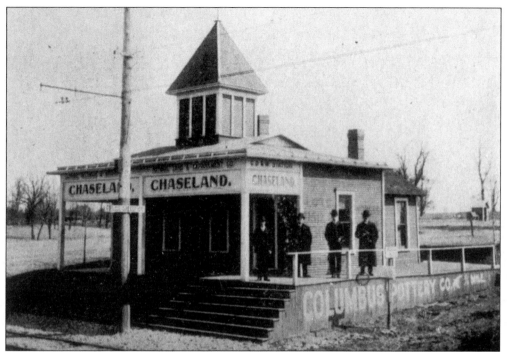

Chaseland appeared in advertisements in 1903 as a "fine suburban addition located on the picturesque Columbus, Delaware, and Marion interurban line with lots ranging from $100 to $300." The developers indicated that Chaseland was named after Bishop Philander Chase, first rector of St. John's Church, who had owned a farm on this site while living in Worthington. (WHS.)

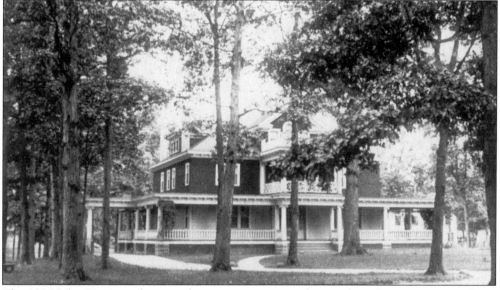

The 1906 John Joyce residence with its interesting steamboat-style architecture was used as a summer estate until its purchase by Dr. George T. Harding, a younger brother of President Warren G. Harding. It became the nucleus for developing the Harding Hospital campus for residential psychiatric treatment programs. (HH.)

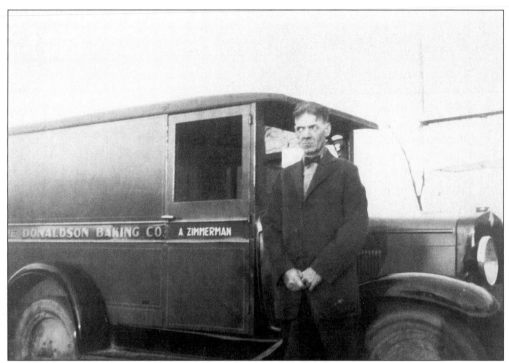

Adolphus Zimmerman was lucky to have steady work driving this bread truck during the employment problems of the Great Depression. From their home on East Granville Road, his wife helped by making large cutout figures of cardboard and selling them to travelers along the highway. (HZ.)

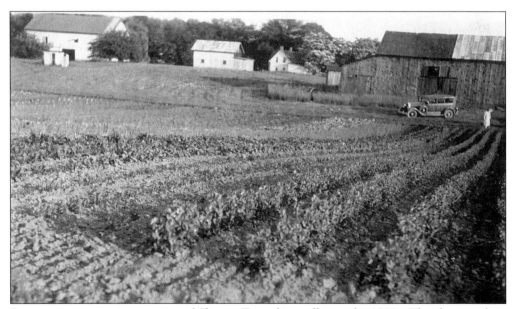

Farm scenes were representative of Sharon Township well into the 1930s. This farmstead, in the vicinity of Camp Mary Orton on Route 23 north of the I-270 outerbelt, reflects the typical small, subsistence farms of that period. (GG.)

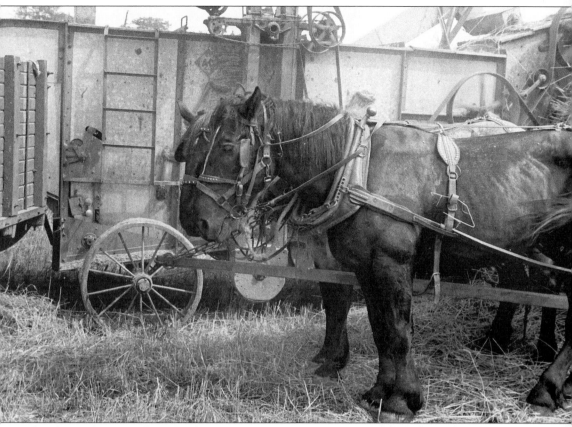

Threshing wheat or other cereal grain crops was one of the major group activities of farming communities in the 1930s, when threshing rings of eight to ten farmers cooperated in the harvest from one farm to the next. This 1938 photograph, taken by Ben Shahn, shows a typical threshing scene where a team of horses had drawn a wagon load of sheaves to the separator, which would thresh the grain from the straw. Threshing also involved other tasks, including pitching the sheaves up to the driver of the wagon with a very long-handled fork. One person was required to bag the threshed grain, so that it could be hauled away from the separator. A young boy or girl usually rode a horse and carried a jug of water to the men working in the field, while a group of farm wives prepared a noon-day feast for the threshers. (LC.)

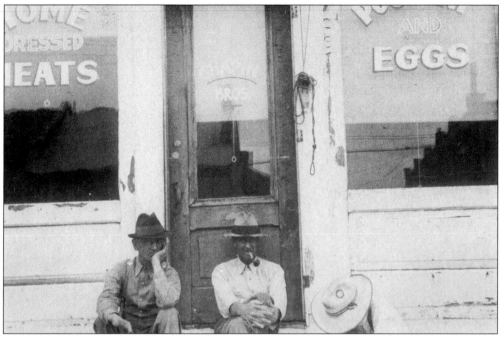

This street scene in Worthington on an August day in 1938 shows three residents resting in front of Chapin Brothers store in downtown Worthington. The scaling paint on the storefront is indicative of the Depression era. (LC.)

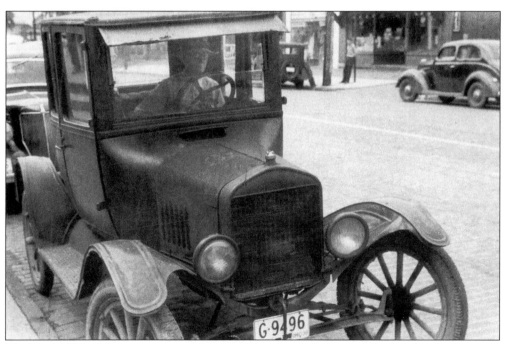

The Model T Ford that is the central feature of this picture had seen at least a decade of service, but was still functioning when this 1938 image was taken. Note the brick paving of High Street and the interesting mixture of automobiles—including two of mid-1930s vintage. (LC.)

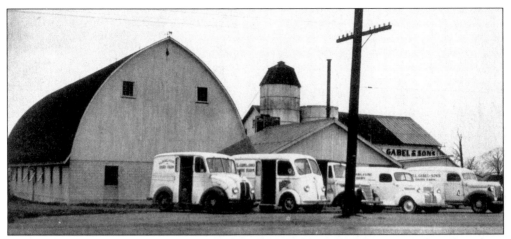

Gabel and Sons Dairy included not only delivery vehicles and a pasteurizing plant, but also a dairy barn and silos in 1942. This farm business served Worthington and combined both farming and marketing from its "country" location. (WCS.)

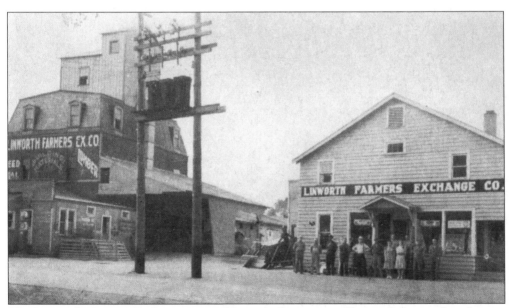

The Linworth Farmer's Exchange was a "Farmer's Cooperative Elevator" that marketed grain, sold feed, and handled lumber as a sideline. Its proximity to the railroad was vital for shipping grain and acquiring lumber. Today, the grain elevator is gone, but the Linworth Lumber Company survives. (WCS.)

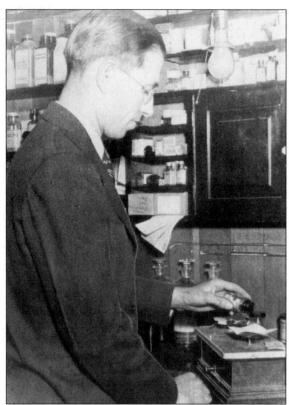

Birnie's Drug Store had moved beyond exclusive use of the mortar and pestle by 1940, but it was still necessary for the pharmacist to prepare a prescription on-site, weighing correct amounts rather than counting pills. Birnie's was independently owned and not part of a drugstore chain. (PW.)

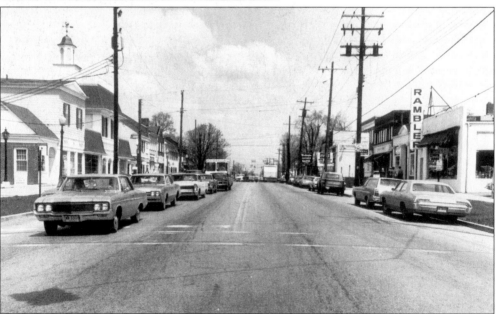

High Street in the 1960s was quite different from a century earlier, and just as different from the street we know today. Utility poles and electric lines have now been buried, and instead of buying cars where the "Rambler" sign is located, one can now purchase ice cream. Each generation takes pride in its modernized downtown. (CW.)

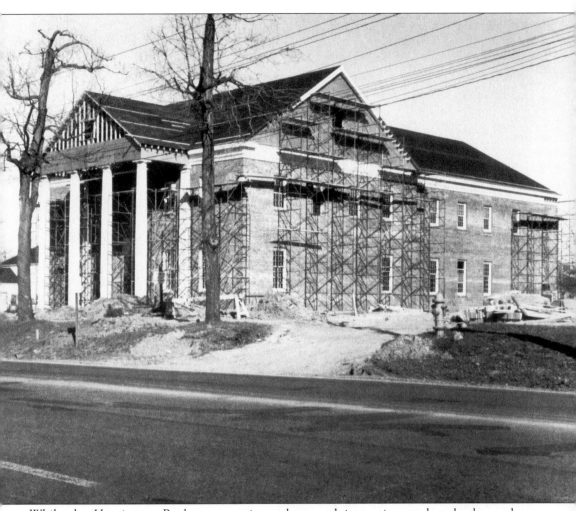

While the Huntington Bank was erecting a large and impressive modern bank on the northeastern end of the Village Green in the 1960s, many Worthingtonians were grieving for the loss of the Griswold Tavern on that site. Although the Worthington Historical Society had been founded nearly a decade earlier, it had been unable to raise the money to preserve the Griswold Tavern. This historical loss was one of the factors that caused the city to pass an Architectural Review Ordinance in the mid-1960s. This ordinance provides a review mechanism for new structures, additions, fences, walls, and signs in historic or architecturally sensitive areas of the community. (CW.)

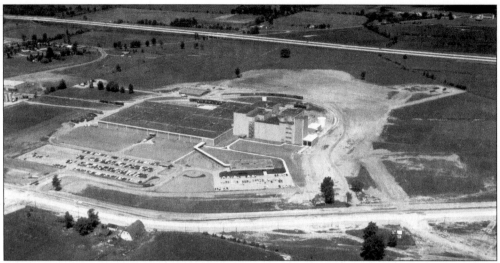

Construction of the Anheuser Busch plant on Columbus land in the Worthington School District had a major impact on school funding, property development, and school enrollment. This 1968 photograph with Schrock Road in the foreground and I-270 in the upper part of the picture shows the plant and vacant land that dramatically changed Worthington schools. (ABC.)

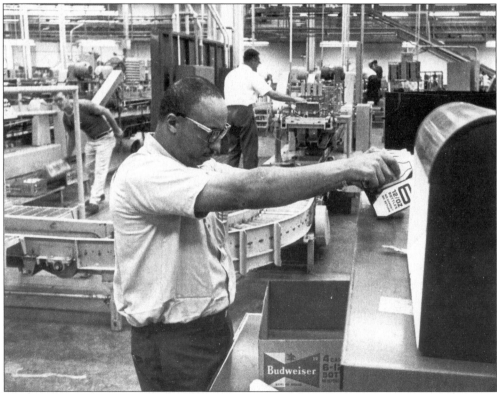

The Anheuser Busch production and bottling line shows production of its popular Budweiser beer. Although a railroad spur was constructed to serve this plant, most of the shipping is by large trucks, which use the nearby interstate highways. (ABC.)

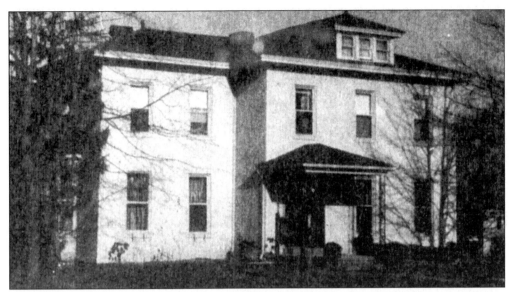

The Ella-Nora Nursing Home was one of the first created to meet the demand for nursing home care in the 1960s. A 1903 home, built for the Jared Jewett family, was converted to a residence for "thirty older guests" and staffed by three licensed practical nurses and four nurses' aides. The building at 579 High Street still stands, but no longer serves as a nursing home. (WACC.)

The Worthington Hardware Store, located on High Street in the downtown section of the village, also sold major appliances. This 1947 photograph not only shows the nature of the appliances available in the post-war consumer boom, but indicates the relatively high prices for this equipment over a half-century ago. (DF.)

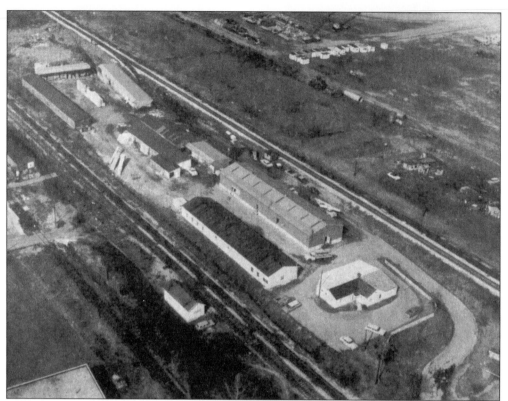

The Potter Lumber Company operated a family business located on East Granville Road between the two railroad underpasses for over 80 years. The company provided building materials, repairs, and remodeling for many local customers who regret its recent closure. (WACC.)

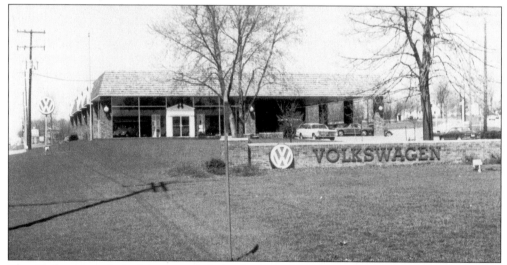

The Volkswagen dealership occupied the key position where Worthington-Galena Road intersects High Street in the 1960s. Changing patterns of land use in the city during the 1990s are reflected in the purchase of this site for the present city of Worthington fire station, while car dealers have relocated in outlying areas with space to display large inventories. (CW.)

Four

PUBLIC SERVICE

When the Worthington pioneers arrived in the West, the pressing need for public service was in the area of law and order and civil affairs. The first line of judicial authority was the township justice of the peace. This was an elected position and despite the Worthington community's Episcopal church commitment, the local marriages were initially performed by justices of the peace.

The Uniform Militia Act, passed by Congress in 1792, required all able-bodied white males between 18 and 45 years of age to be enrolled in the militia, with exemptions for certain disabilities or religious beliefs. Officers up to the rank of captain were elected by the troops, while field-grade officers were elected by company officers. The militiamen were required to train at least twice a year, but the "muster days" were often social affairs that featured more liquor than military drills.

Worthington was incorporated as a village in 1835, and the act called for an elected mayor, a recorder, and five village council trustees, who had the power to appoint a treasurer, a marshall, and "other officers" as needed—including fire wardens. Township trustees and county commissioners were responsible for the roads in the area. It was not until 1956 that Worthington became a city.

Public utilities became available in Worthington as follows: (1) telephone communications between Columbus and Worthington—May 23, 1881; (2) electric street railway connection between Clintonville and Worthington—December 1893; (3) electric service—1894; (4) brick paving for sidewalks—1894; (5) gas available in the village—1904; (6) water for the village—1913; (7) electric street lights—1915; and (8) sewers in village—1920. The street railway was privately owned, but did perform a public service.

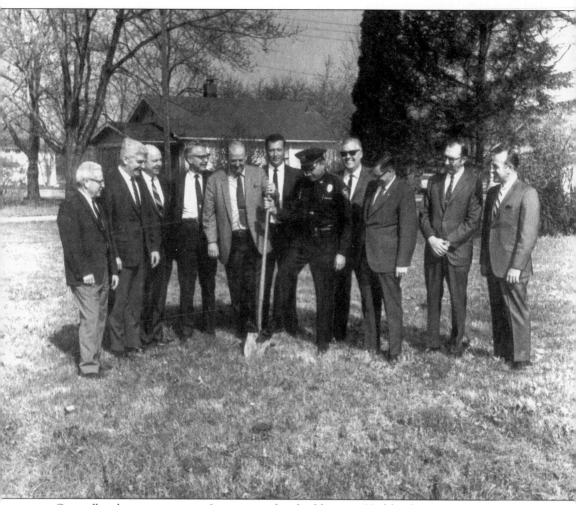

Groundbreaking ceremonies for a new safety building on Highland Avenue in Worthington were held April 20, 1966, a decade after population growth passed 5,000 and it officially became a city. Prior to this the town marshall provided security and the village had a jail, but in 1956 Worthington moved to a city manager and city council form of government. Persons in the above picture are, from left to right, as follows: C.D.Kellar (service director), J.P. Coleman, J.W. Hogan, and C.E. Williams (council members), L.T. Smith (council president), G. Scwippel (contractor), P.R. Abbott (chief of police), T.A. Reed (architect), G.H. Shapter (city manager), D.W. Horch (finance director), and A.E. Levulis (director of administration). (CW.)

IN THE NAME AND BY AUTHORITY OF THE STATE OF OHIO.

ALLEN TRIMBLE, *Speaker of the Senate,*

Acting as Governor and Commander in Chief of said State.

To all who shall see these presents, GREETING:

KNOW YE, That *Aurora Buttles* Esq. being duly elected to the office of Justice of the Peace, for the Township of *Sharon* in the County of *Franklin* and State aforesaid: THEREFORE, by virtue of the powers vested in me by the Constitution and Laws of the said state, I do commission him the said *Aurora Buttles* Esq. as a Justice of the Peace for said Township, hereby authorising and empowering him to execute and discharge all and singular the duties appertaining to said office, and to enjoy all the privileges and immunities thereof, for and during the term of three years from the date hereof, agreeably to the constitution and laws of this State. In testimony whereof, I have hereunto set my name, and caused the GREAT SEAL of the State of Ohio, to be affixed at Columbus, the *twelfth* day of *November* in the year of our Lord, one thousand eight hundred and twenty-two and in the forty-seventh year of the Independence of the United States of America.

BY THE GOVERNOR,

_____ Secretary of State. *Allen Trimble*

Arora Buttles's commission as justice of the peace in 1822 reflects the most important legal office in early nineteenth-century Worthington. James Kilbourn was elected to this office in 1805 and a succession of Worthington men followed him in performing marriages, resolving conflicts over debts, writing deeds to convey property, administering oaths of office, and appraising and advertising stray animals. (RWM.)

George H. Griswold, son of the original settler, Ezra Griswold, followed his father in performing as justice of the peace and served the village in many public roles during the more than 50 years that he operated the Griswold Tavern in Worthington. He was elected as recorder when the village was first incorporated in 1835 and completed several terms as mayor. (*History of Franklin and Pickaway Counties,* 1880.)

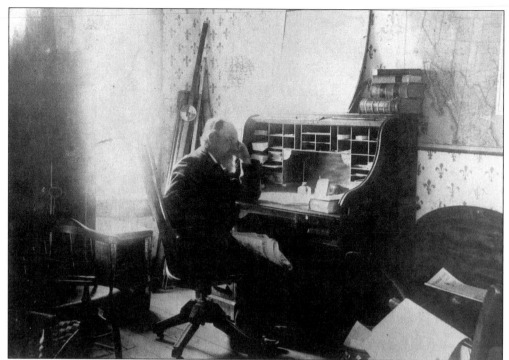

Worthington Franklin Griswold, son of George H., is seen in his office. He was also active in the governance of the village of Worthington, becoming a member of the council in 1866, elected mayor in 1883, and serving as treasurer for many of the intervening years. He also performed the duties of a justice of the peace. (TC.)

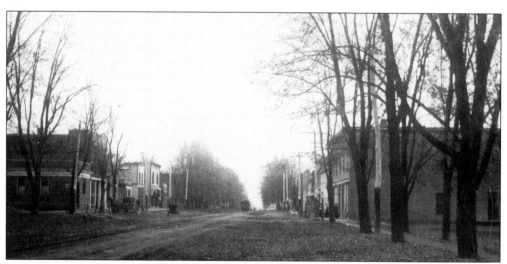

Main (now High) Street at the turn of the twentieth century shows the interurban railway tracks in the middle of the street. Even with several horse-drawn buggies tied up in front of downtown businesses, it is very clear that Worthington was then a sleepy little village. The population of approximately 400 persons was nearly the same as it had been in 1840 shortly after the village was incorporated. (TC.)

This view of East State Street (now Dublin-Granville Road), apparently taken about the same time and from the same location as the Main Street photograph, provides a similar perspective of the unpaved road east to the railroad tracks. Scattered residences often had fenced yards as a protection against livestock, and farm wagons provided the major source of traffic. (TC.)

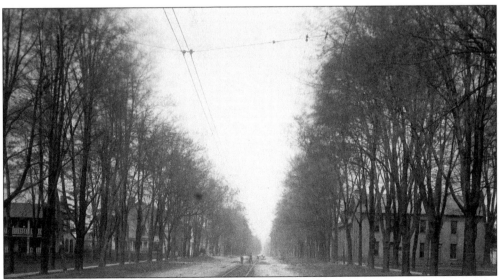

North Main (now High) Street as it appeared from the public square around the turn of the century shows the interurban tracks north to Delaware. The Griswold Tavern is at the right on the site now occupied by the Huntington Bank parking lot, and on the far left the Tuller home with a gallery porch is now the site of the Griswold Center. (TC.)

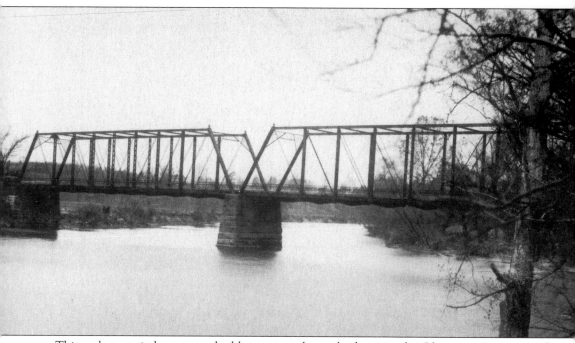

This early twentieth-century, double-span, steel-truss bridge over the Olentangy River carried the Elmwood Road, which was later named the Dublin-Granville Road (Rt. 161). This crossing of the Whetstone (later the Olentangy) River has been of importance to Worthington from the pioneer period to the present day. Fording the stream on horseback was the initial means of crossing by postal carriers and others prior to the construction of a bridge. During periods of heavy rain, the postal carrier stayed at the Griswold Tavern until the water subsided. In 1820 efforts began to construct the first covered wooden bridge over this stream to improve the delivery of mail and to provide for better communication between settlers on the west side of the river with the remainder of the Worthington inhabitants. (WHS.)

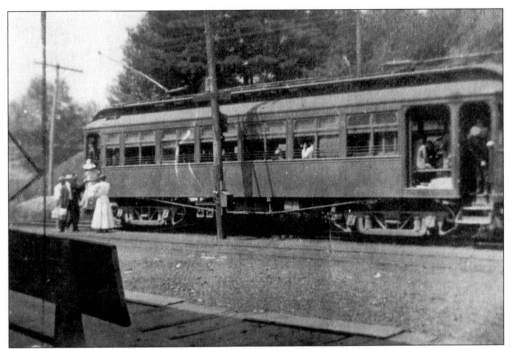

Passengers boarding the Columbus, Delaware, and Marion (CD & M) interurban car could by 1902 enjoy the convenience of speedy transportation south to the capital city or north to Delaware and Marion. It was an extension of the 1893 electric street railway from Clintonville to Worthington that created the infrastructure that began to transform Worthington into a residential suburb. (IPC.)

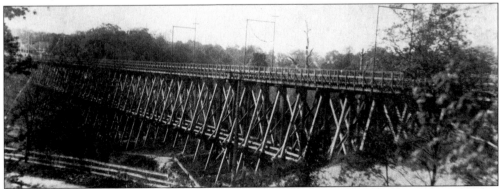

This impressive wooden trestle carried the CD & M tracks north across the steep ravine that existed where the entrance to Camp Mary Orton is today. The area near this ravine was known as Slate Hill, since the soil contained shale that looked very much like slate. The trestle was demolished after the interurban line was abandoned in the early 1930s, and much of the ravine has been filled in to accommodate improvements to State Route 23. (IPC.)

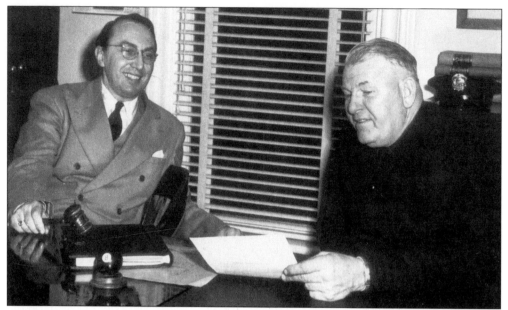

Worthington Mayor George Wing and Worthington Marshall James Taladay discuss village security in the council offices on the second floor of the Jones Building at 693 High Street. George Wing was the last elected mayor of the village from 1945 to 1955, and Taladay had long service as the village marshall. (WHS.)

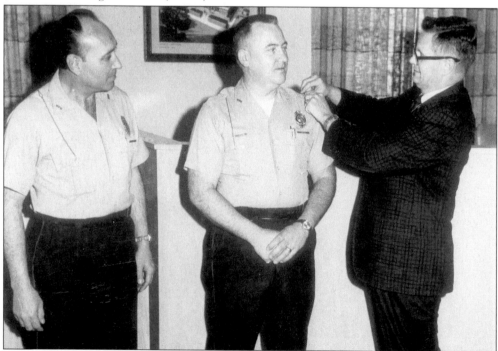

The commissioning of new members of the Worthington police force reflects the rapidly expanding population and Worthington's change to city government in 1956. Police officers were achieving recognition as law enforcement professionals with appropriate training. (WHS.)

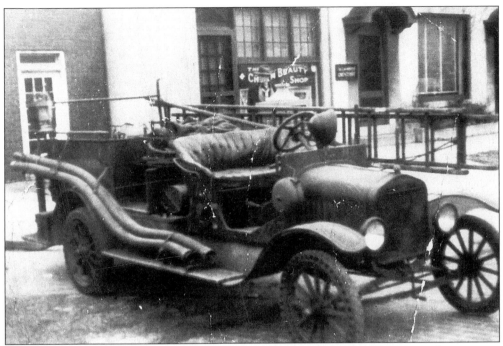

This 1917 Model T Ford truck, equipped with a pumper, was the first piece of equipment purchased when an official Worthington Fire Department was organized in 1916. The department included a chief, assistant chief, and a maximum of 15 part-time firefighters. Before the village installed a water system in 1913, Worthington's fire protection was provided primarily by volunteers with buckets and ladders. (CW.)

A water pumping station erected on the school farm—on the high ground where the swimming pools are now located—was an important component of the water system of Worthington when it was installed in 1913. A number of wells were drilled just east of the river, and the pumping station conveyed water uphill to a water tower east of High Street. This system was used until the early 1960s when Worthington contracted with Columbus for its supply. (CW.)

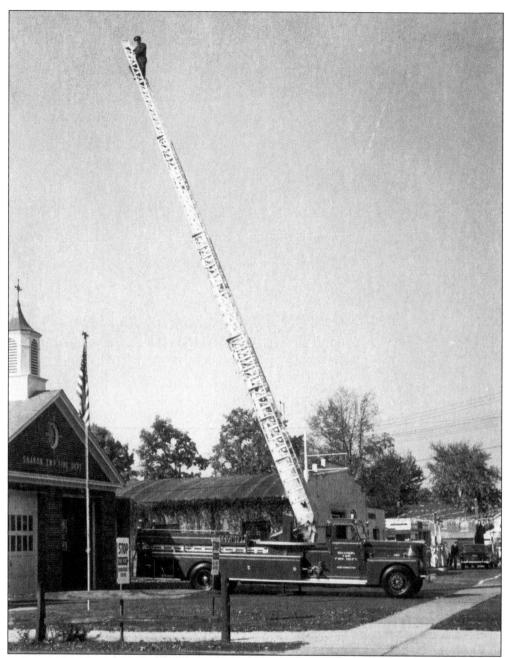

A fire truck with an aerial platform that extended 100 feet was purchased for $228,190 by the Sharon Township Fire Department, which then served both Worthington and the township. Commercial growth in outlying areas made it increasingly necessary to have unified fire protection and larger firefighting equipment. It was a massive improvement from a century earlier when fire wardens enlisted volunteers with buckets and ladders—and later hand-operated pumps. The village's first "fire engine" was a chemical engine purchased in 1899, since there was no public water system until 1913. (STFA.)

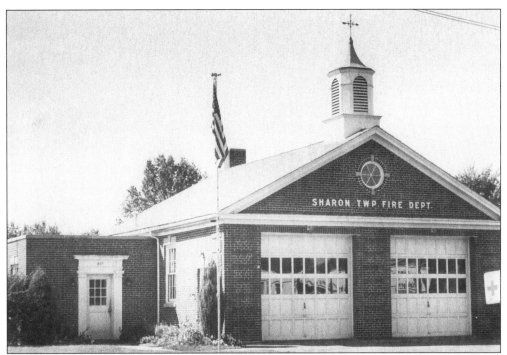

This Sharon Township Fire Station was constructed on High Street in 1949–1950, just north of the present Griswold Center. Initially, it had only the two bays, with a small office facility on the south side shown on the left of this photograph. It was a spacious and convenient building compared to the department's previous facility on the south side of the township hall with an entrance from Hartford Street. (WHS.)

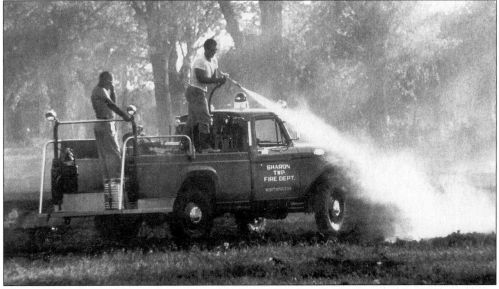

This pumper was added to the Sharon Township Fire Department arsenal of equipment in 1952. At that time, only a custodian was housed at the fire station, and unlike today when a paid firefighting force stands ready at all times, a siren was sounded to summon firefighters when needed. (STFA.)

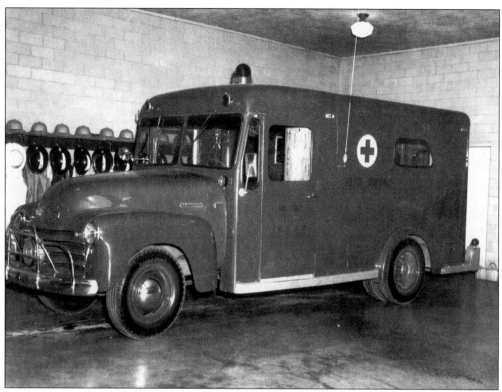

This emergency squad vehicle was the Sharon Township Fire Department's first in 1953. Assuming the responsibility of caring for fire and accident victims required new skills and extensive training for the volunteer personnel who operated this vehicle. (STFA.)

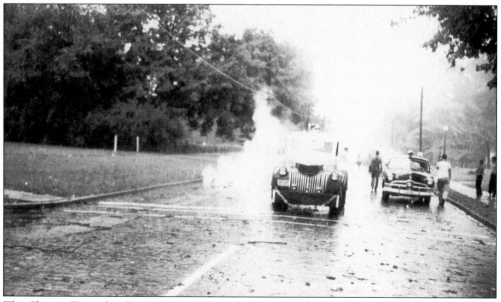

The Sharon Township Fire Department crew at work in this 1950s photograph clearly shows the brick street that was characteristic of Worthington at that time. It looks as though there has been a storm and perhaps downed utility lines. (STFA.)

The last Worthington City water tower stood in the city service area on Highland Avenue, approximately where the salt shed for icy roads currently stands. It was erected after Worthington became a city to serve the rapidly expanding residential and commercial development, which was creating water pressure problems in the Worthington area. (CW.)

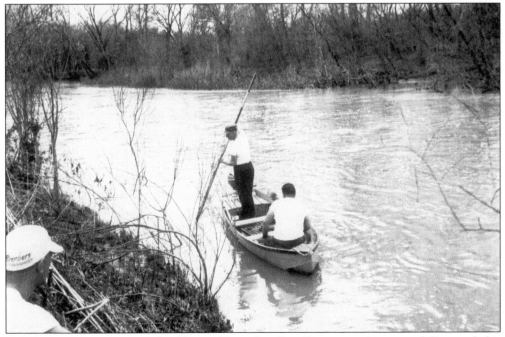

River rescues were part of the Sharon Township Fire Department's responsibility, and this photograph taken in the 1960s shows fire department personnel training on the Olentangy River. (STFA.)

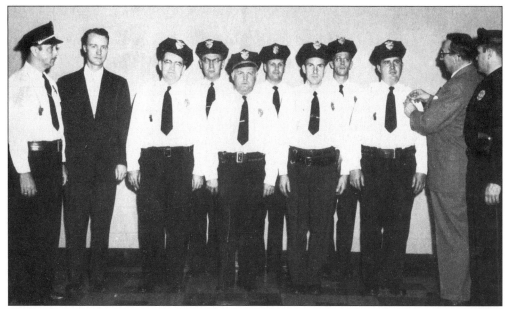

This police commissioning ceremony in May 1964 shows Worthington Chief of Police P.R. Abbott (on the left) watching Worthington City Manger G.H. Shapter pin lieutenant's bars on Lt. F.M. Reeves. (CW.)

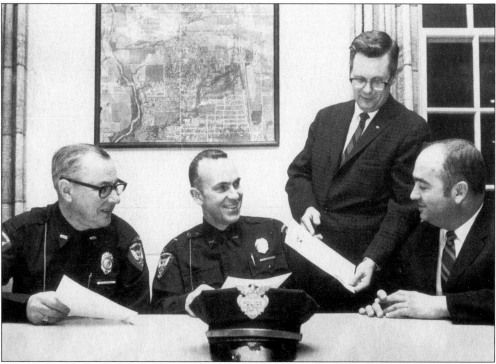

Reserve Worthington police officers seated left to right in the above photograph are Reserve Captain Richard Trimble, Reserve Lieutenant Harry Zimmerman, and Reserve Sergeant William George. They are conferring with Worthington City Manager G.H. Shapter, who stands in the rear. (CW.)

The Worthington Municipal Building and the Sharon Township Fire Station were photographed sometime between 1954 and 1957, since the sign on the municipal building reads "Village of Worthington" and an additional bay has been added to the north side of the fire station. Worthington was entering its development boom at this time. (WACC.)

Construction of Route 315 is shown passing beneath the Wilson Bridge Road crossing prior to the I-270 entrance ramp. The interstate highway (I-270) became the northern boundary of the city of Worthington, confining its future growth, but not that of the Worthington School District, which extended to the Delaware County line. (CW.)

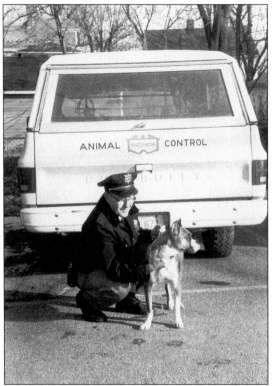

Animal control has been added to the responsibilities of the Worthington Division of Police. City ordinances do not permit domestic animals such as dogs and cats to run at large, and require pet owners to clean up after their animals when they are walked in public parks or streets. Animal complaints constitute a significant percentage of the complaints received by the Worthington Police Department. (WCS.)

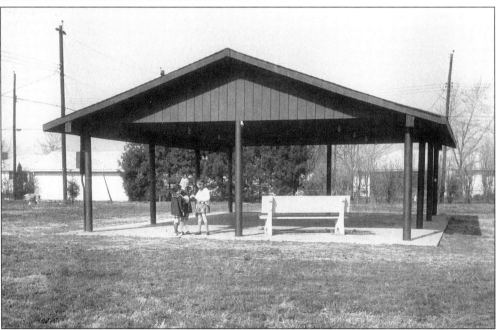

The Wilson Hill Park shelter house demonstrates the efforts of the Worthington Parks and Recreation Department to provide appropriate neighborhood parks throughout the city. When the Wilson Hills subdivision was developed in the late 1950s and early 1960s, this park was created with children's play equipment, a picnic area, and lighted tennis courts. (CW.)

Tree planting along High Street is illustrative of the efforts that began in the 1960s and continue today to improve the streetscapes throughout "Old Worthington." The city now has a tree committee that recommends appropriate urban varieties, such as the serviceberry shown on the right, and local schools regularly participate in Arbor Day tree-planting programs. (WCS.)

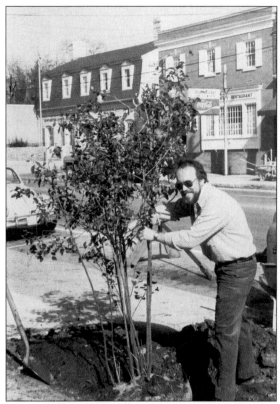

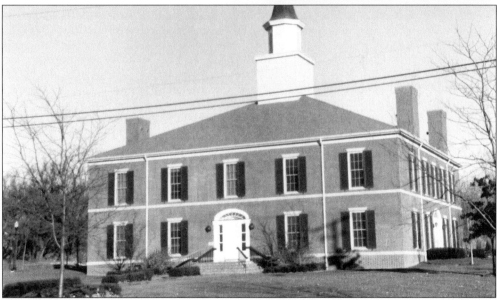

Worthington City Hall on North High Street was controversial in 1991 when voters approved its construction outside the boundaries of "Old Worthington" to obtain more space and more parking than was available near the Village Green. Its design was based upon the first Ohio State Capitol building and typifies the classical architecture the Worthington Architectural Review Board encourages in order to preserve the city's New England heritage. (VEM.)

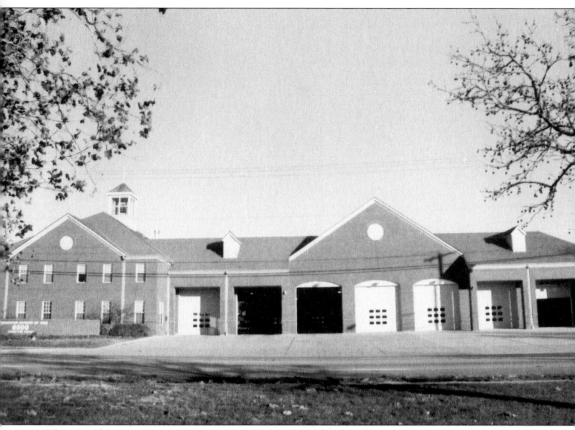

The Worthington Fire Station was erected in 1991 by the Sharon Township Trustees, which was two years before the fire department was transferred back to city control after 60 years under township supervision. The department continues to serve both city and township, but its administration reflects the reality that practically all land in the township has now been developed and much has been annexed to the city of Worthington. This seven-bay facility was designed with drive-through access, and its location north of "Old Worthington" business center reflects the growth of offices, hotels, restaurants, and warehouses near the interstate highways in the northern part of the city. (VEM.)

Five

COMMUNITY ORGANIZATIONS AND NEIGHBORHOODS

Throughout the nineteenth and twentieth centuries Worthington has had a number of community organizations that became more varied as the population increased.

Although the Masonic Lodge is the oldest organization in Worthington, the past two centuries have offered citizens a wide variety of opportunities to join like-minded others in fraternal lodges, literary societies, musical groups, veterans' organizations, theater groups, hobby and craft groups, and arts and historical societies. The images shown here are representative, but by no means completely inclusive, of these organizations.

The first Worthington subdivision was the Morris Addition platted in 1856. Some subdivisions, such as Colonial Hills, developed in Sharon Township and voted to annex themselves to the village of Worthington, but more frequently—such as Wilson Hills and Worthington Estates—developers sought annexation and city services before erecting buildings. Some neighborhoods like Riverlea—although completely surrounded by the city of Worthington—chose to retain their autonomy and elect their own mayors but contract with Worthington for services. Outlying neighborhoods, like Flint and Linworth, developed around railroad stations in Sharon and Perry Townships and had a distinct community identity, although they were never incorporated.

There are many more neighborhoods in the city of Worthington and in the Worthington School District today than are illustrated in this chapter. These are simply representative. The population of the city of Worthington had its most rapid growth between 1950 and 1970 and has remained constant since that date at about 15,000. The population of the Worthington School District has continued to grow until the present time and is currently about 55,000. It is not likely to increase substantially in the future because the land is fully developed.

The Worthington Cornet Band was one of many such community bands during the late nineteenth century. Although it is not known just when they were organized, the Worthington band was engaged to play for the 1881 school commencement exercises, and they obviously played for other community activities as well. This picture, taken on the Public Square with the Griswold Tavern in the background, shows that this was a brass band with varied instruments from trumpets to trombones. Their uniforms appear to be confined to caps—worn with dark jackets and ties—and the presence of American flags suggests that this band originated, like so many other community bands, from the patriotic military bands of the post-Civil War era. (TC.)

New England Masonic Lodge No. 4 is the oldest community organization in Worthington. It was chartered October 19, 1803, through the Grand Lodge of Connecticut before the pioneers came west. Thirteen members of the Scioto Company were Master Masons, and James Kilbourn was elected the first master of this lodge. Their brick building, erected by Arora Buttles in 1820 with Masonic symbols in the gable, is now a Masonic museum. (WHS.)

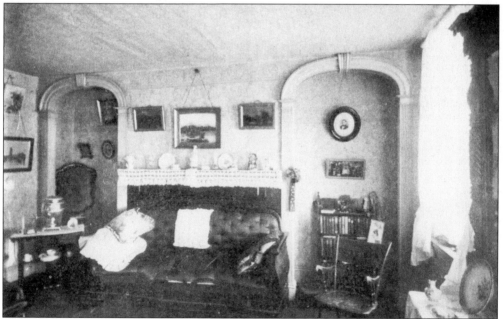

Masonic symbols in the living room of John Snow's home on West New England Avenue reflect his extreme interest in Masonic activities and his election not only as master of the local lodge but as the first grand commander of the Mt. Vernon Encampment of Knights Templar. Snow came to Worthington to become involved with the retail store of the Worthington Manufacturing Company. (*Old Northwest Genealogical Quarterly*, October 1903.)

The Moose Home Lodge 1427 was in this building on High Street just south of the village. It was the "old Parsons property" and then in the 1920s "Ye Olde Chase Tavern." The site at 5935 North High Street is now occupied by condominiums, and the Moose Lodge has moved into larger facilities on Crosswoods Drive north of the outerbelt. (IPC.)

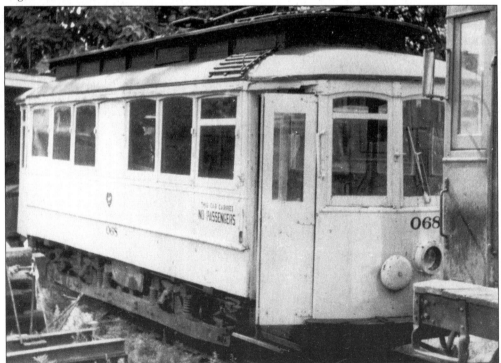

The Ohio Railway Museum located at 990 Proprietors Road adjacent to the railroad tracks collects trolley and steam equipment, and volunteers restore them to workable condition. On Saturdays and Sundays from May through October a variety of short excursions offer visitors the opportunity to ride this old-time rail equipment—a particularly popular activity with families and youth groups. (IPC.)

Commanders of the Worthington American Legion Post from 1920 to 1957 are shown above. Named the Lawrence Leasure Post to commemorate the son of the village pharmacist who died after a month's service during World War I, it became the Leasure-Blackston Post after World War II to honor local serviceman Tad Blackston, who was fatally injured in an airplane accident in April 1943. The American Legion owns a building located at the rear of the Sharon Memorial Hall on East Granville Road where meetings and social activities are held. In addition to a number of social-service activities, the Legion is responsible for organizing the Worthington Memorial Day Parade each year. (ALP.)

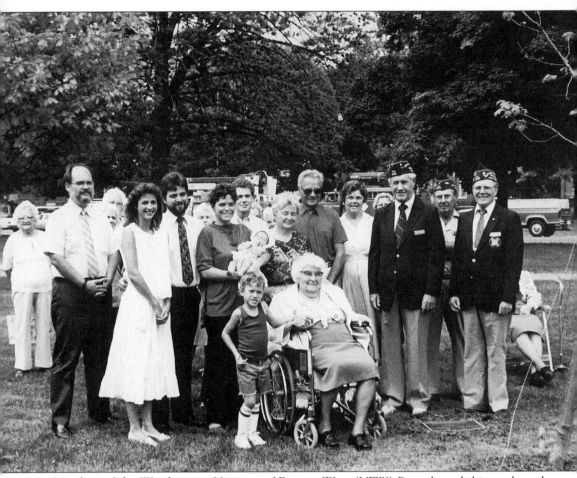

Members of the Worthington Veterans of Foreign Wars (VFW) Post planted this scarlet oak tree on the Village Green to recognize the contribution of Myra and Newell Middleton in advocating the need for a Senior Center in Worthington. Shown above with Mrs. Middleton and her family are, from left to right, VFW representatives Commander Pat Collins, Quartermaster Normand Blain, and Past Commander Richard Long. The VFW post is active in a number of community events each year. They share the use of Sharon Memorial Hall with the Sharon Township Trustees and Police, since this facility was purchased by a special levy approved by local voters in November 1945 to commemorate local war veterans. (VFW.)

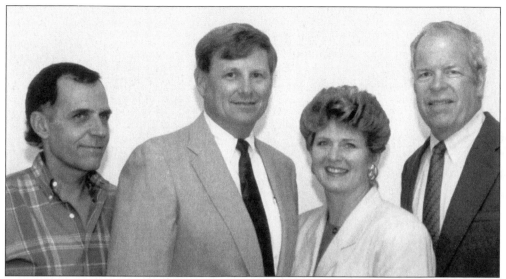

The Worthington Chamber of Commerce has been active for more than 50 years, but in 1983 the first president employed by the organization was Ruth Barnett. She is shown above with Dwight Moody and Dr. Thomas Hull on the left, and on the right Steve Potter, all who had been selected as Small Business Person of the Year during her tenure. (WACC.)

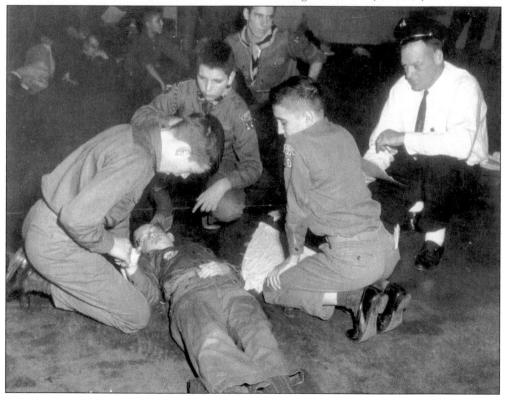

Boy Scouts learning first aid procedures from emergency medical personnel of the Worthington Fire Department reflect one of the many Boy Scout and Cub Scout troops in Worthington who earn badges by learning such skills. (STFA.)

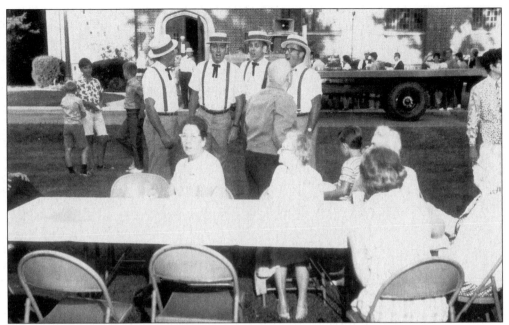

The Worthington Historical Society ice-cream social is a popular social activity on the Village Green each summer. With home-baked cakes contributed by society members, ice cream donated by local businesses, and entertainment by groups such as the barbershop quartet shown above, it is a great way to have a good time while raising money for historical society programs. (CW.)

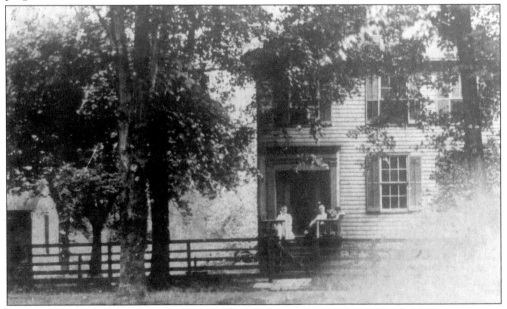

St. John's Episcopal Church members built the rectory between 1841 and 1845 to attract a rector to the parish. The above photograph from the turn of the century shows one of the 15 rector's families who lived in this Greek Revival residence during the next 80 years, and it reveals how authentically the Worthington Historical Society has restored the building to its original appearance. (WHS.)

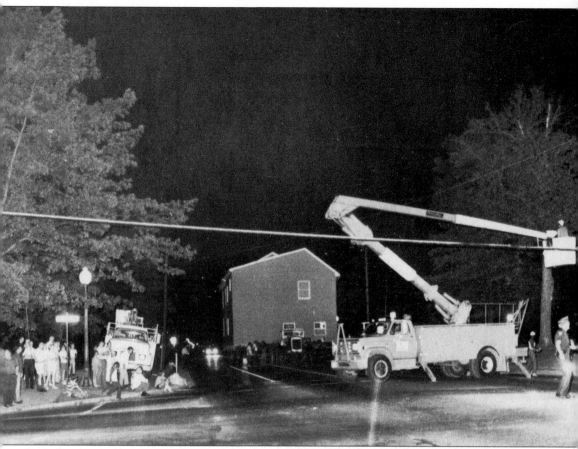

High Street was closed to traffic for the night and utility companies disconnected their wires, but quite a crowd turned out to see "The Old Rectory" make its way down the street on its way to New England Avenue to take on its new role as the Worthington Historical Society headquarters. Actually this was the rectory's second move; St. John's Episcopal Church had sold it in 1926 to make room for a new parish house south of the church facing the Village Green. The rectory was moved to 799 Hartford Street and served as a rental property until 1965 when it was purchased by the Worthington Board of Education for administrative offices. The historical society purchased it in 1978 when the Worthington Public Library acquired the site from the school district for a new library building. (WHS.)

The Worthington Players Club members above are taking a bow for their presentation of *Outward Bound* in June of 1950 in the auditorium of the current Kilbourne Middle School. Performers pictured above, from left to right, are Ellwood Spring, Jack Kennard, Mary Schier, Robert Greene, unidentified, Hugh Flaherty, Vera Spring, Donna Moore, and Betty Peffer. (H&SF.)

Entrance markers on the four major streets entering the boundaries of the original Worthington village are one of the community service projects of the Worthington Women's Club, which was organized in 1932 "to learn, to teach, to serve, to enjoy." A decade later they commissioned these wrought-iron markers featuring St. John's Episcopal Church, Worthington Academy (on the left), Griswold Tavern, and a pioneer ox team and cart. (VEM.)

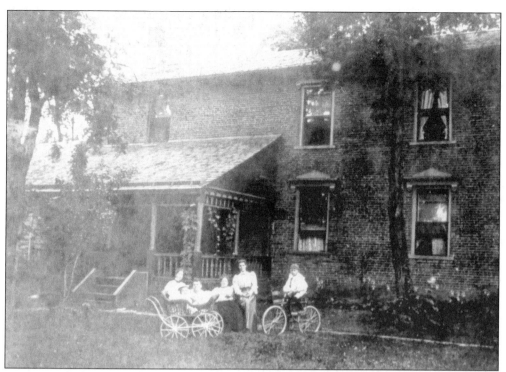

Homes within the bounds of "Old Worthington" between North, South, Morning, and Evening Streets had not changed dramatically by the turn of the century. Worthington was a quiet village—a good place to raise a family. For the Cynthia Weaver family at 12 East Stafford Avenue, the backyard of this 1818 residence was part of a safe neighborhood for riding bicycles and pushing doll buggies. (WHS.)

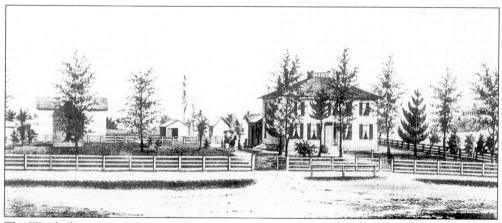

The Wright home on East Granville Road—now Sharon Memorial Hall—was erected on four adjacent lots in Worthington's first subdivision. The Morris Addition, platted in 1856, contained 188 lots bounded by Morning Street, Granville Road, Andover Street, and South Street. Outbuildings to accommodate carriages, horses, family milk cows, and poultry were common for most homes in the village in the latter part of the nineteenth century. (WHS.)

Queen Anne-style homes, "American four squares," bungalows, and Colonial revivals were typical of the residences built during the last decade of the nineteenth and the first years of the twentieth century along Old Worthington side streets and east and west along Granville Road. The completion of the electric street railway in 1893 made Worthington an attractive neighborhood for businessmen who commuted to Columbus. The early twentieth century found carriages giving way to motor cars, and development accelerated along the tree-lined streets of old Worthington—particularly in the southern quadrants along Hartford and Oxford Streets where gathering on the spacious front porches of the homes was an everyday pleasure. This photograph taken in the 1920s from the top of the female seminary building shows houses at 590 and 594 Hartford Street and the area of the 1856 Morris Addition. (WHS.)

Edwin Albaugh's retreat in the Kenyon Brook ravine just south of Worthington, as sketched by Bill Arter, shows that in the early part of the twentieth century the tranquility of the village was attracting Columbus residents searching for a summer home or a retirement retreat. Albaugh was an artist, inventor, and mechanical genius who became world famous for his ball-bearing clocks and antique jewelry—many crafted in his workshop at this site. (WHS.)

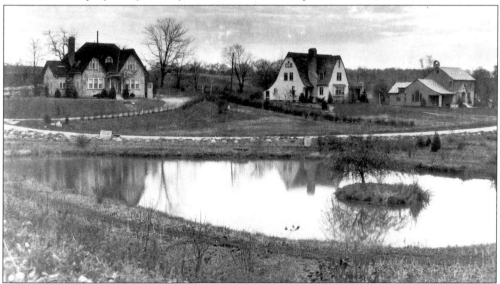

These homes in the Kenyon Brook neighborhood were built in 1930 on lots purchased from Mr. Albaugh—just before the Great Depression halted additional construction. This entire area had originally been part of the farm owned by Bishop Philander Chase, who founded Kenyon College at his farm home where St. Michael's Catholic Church is today. (W&WD.)

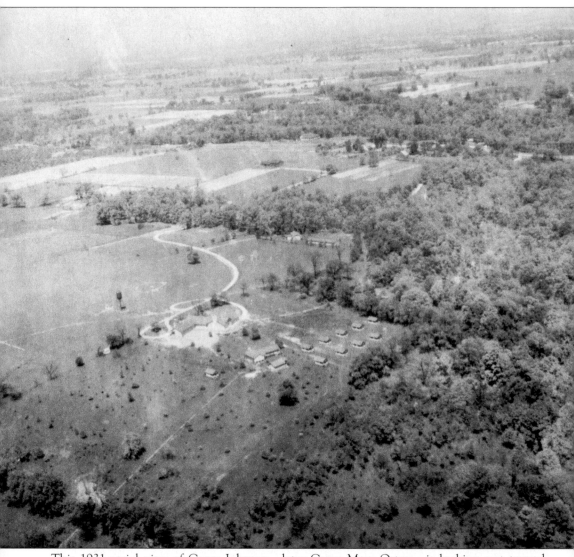

This 1931 aerial view of Camp Johnson—later Camp Mary Orton—is looking east toward present-day Route 23. The heavily wooded area to the right is a deep ravine and a close look on the upper right shows the CD & M wooden trestle. Except for the ravine, all of the land around the camp is obviously productive farmland—prized by the pioneer setters, but now developed for commercial and industrial use. This camp had its own water system as evident by the water tower shown in this picture. (GG.)

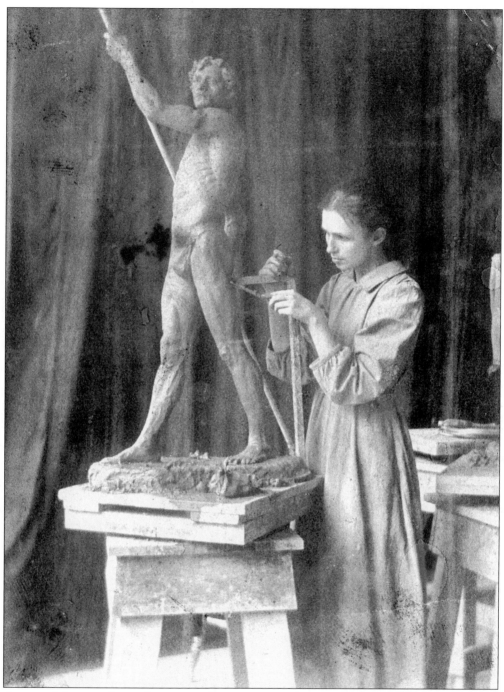

Annetta Johnson, shown here at work as an art student in the New York City studio of Augustus St. Gaudens, grew up at Twin Oaks on Flint Road and donated a portion of her parents' farm to the Godman Guild to establish Camp Johnson as a retreat for urban children. She later married Louis St. Gaudens, brother of her mentor Augustus, and became a nationally recognized sculptor. She created the bust of the first president of Ohio State University, Edward Orton, now displayed in the geology library at the university. (NPS.)

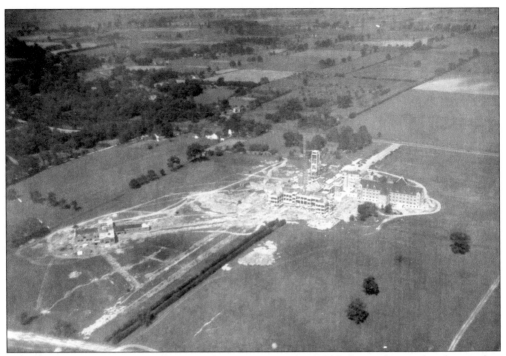

This aerial view of the Josephinum under construction in 1930 shows the rural isolation that provided a "quiet air" for student contemplation at that time. Missing from this picture is the present I-270 outerbelt and the Worthington interchange, the Worthington Mall shopping center, and the numerous residential and commercial buildings that have been constructed in this area since World War II. (PJ.)

"Boulder Lodge," the 1930s limestone residence of Frank and Nellie Medick is the landmark of the Medick Estates neighborhood. Frank Medick began developing the "Clear View" addition in the northwestern quadrant of Old Worthington in 1929, and purchased the farmland west of it as far as the river for estate homes. But the Depression and World War II intervened, and most homes in Medick Estates were not erected until the 1950s. (WHS.)

"Colonial Hills and Dales," south of Worthington, was laid out as a subdivision prior to World War II, and homes like the one above were built as housing for workers at the Wright airplane factory near Port Columbus. These were rental units until after World War II when they became popular "starter homes" for the young couples who were creating the "baby boom" generation. (RWM.)

Backyard swing sets were common in this neighborhood—now called simply Colonial Hills. In 1954 voters approved its annexation to Worthington, an action that was instrumental in providing Worthington with sufficient population to become a city. The influx of children caused the Worthington School Board to build Colonial Hills Elementary, a part of a school construction program that would extend for 40 years. (RWM.)

South Street in 1955 was barely a country lane as it traversed the wooded area around Rush Creek at the southeastern corner of Old Worthington. This was originally a 20-acre woodlot for St. John's Episcopal Church—land too rough for farming, but ideally suited to Martha and Richard Wakefield's desire to interpret Frank Lloyd Wright's organic architectural concepts in central Ohio. (MW.)

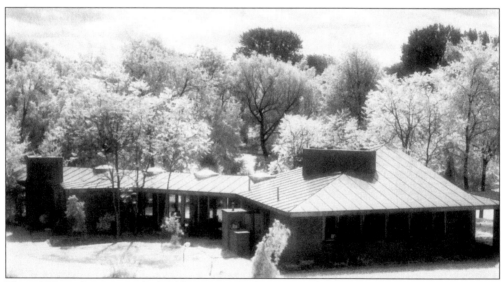

The 1955 single-story Wakefield home was built on a 45-degree diagonal that allowed living areas to open to a private courtyard terrace with a reflective pool. This house established the style for a unique neighborhood that eventually included 48 organic homes. (MW.)

Toll Gate Square at the northern edge of Old Worthington was the first condominium plat filed in Franklin County in 1963. The name was derived from an early Columbus to Delaware toll road, although the nearest tollgate was at the county line. The by-laws of this condominium association became a model for adult residential communities, and the concept of private ownership of one's residential unit with shared ownership of surrounding common space is now very popular. Toll Gate Square also became a model of compatibility with the New England architecture of the early nineteenth-century village. Its site adjacent to the Worthington Historical Society property at 956 High Street was particularly sensitive, and its resolution became a model for construction within the Worthington Architectural Review District. (VEM.)

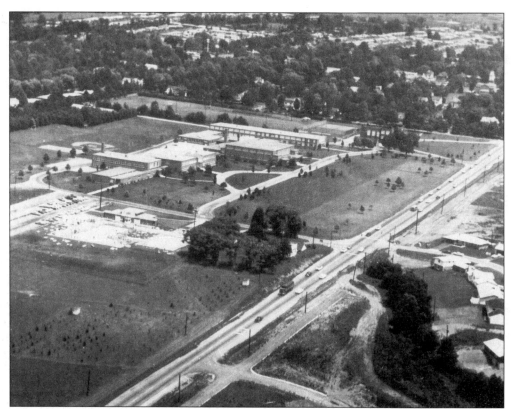

This 1960 aerial view of the neighborhoods surrounding Worthington High School shows construction in the Kilbourne Village subdivision on the right. There is a treeless group of homes in the Wilson Hill subdivision at the upper left, and at the top of the photograph there is open farmland near Proprietors Road. (WCS.)

This recently built home on Crandall Drive reflects the Wilson Hill neighborhood of ranch and split-level homes about 1960 when trees and shrubs were beginning to soften its raw newness. Note the open aluminum windows, which reflect a lack of central air conditioning. Similar subdivisions in Kilbourne Village and Worthington Estates attracted young families and created the need for a new elementary school in each of these neighborhoods. (RWM.)

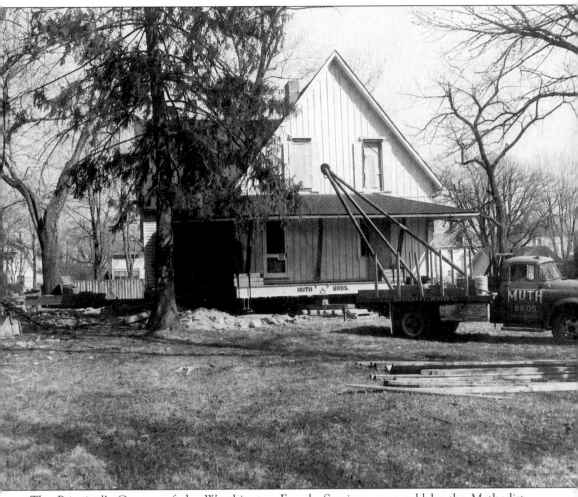

The Principal's Cottage of the Worthington Female Seminary was sold by the Methodist church in 1962 in preparation for constructing their new building and parking lot. Purchased by Charles and Janet Lee as a private residence, it is seen here ready to be moved across High Street, to be renovated to its 1871 Carpenter Gothic appearance and christened "Bird Song." It still stands behind Maple Lee Flowers—the only surviving structure from the Worthington Female Seminary and Ohio Central Normal School. It is an excellent reminder that the buildings of nineteenth-century Worthington were primarily built north and south along Main (now High) Street. Many of these were demolished by commercial progress, but, like the Principal's Cottage and the Old Episcopal Rectory, a few have been moved to side streets and lovingly restored. (CL.)

The log cabin shown in this 1940 picture was built as a recreational retreat on Lake Robert Poste—also known as Sinclair Lake—on the east side of the railroad tracks and just south of East Granville Road. Dwight, Ann, and David Moody are standing by this cabin which, without the porch, still stands as the living room of the Dwight Moody residence. (DM.)

This Hopewell Indian Mound was retained as the centerpiece of the drive that circled the Plesenton subdivision when it was platted in the 1950s. Taken by Timothy Armstrong from his driveway, this photograph shows some of the new homes on the far right. His wife, Mary Edge Armstrong, was the first president of the Worthington Historical Society, which today owns and maintains this prehistoric mound. (WHS.)

Six

CELEBRATIONS, RECREATION, AND LEISURE

Celebrations in Worthington have occurred since the early founding of the village. On the Fourth of July in 1804, the settlement celebrated by felling 17 large trees on the Public Square. The sound of the tree falling substituted for the firing of a gun, and the number 17 represented Ohio's rank in states admitted into the United States. The Fourth of July continued to be a major occasion for celebration during the nineteenth and the early twentieth centuries. Today, the largest celebration is the annual Memorial Day Parade, an extended procession of organizations and people marching from Morning Street and East Granville Road down High Street to the Walnut Grove Cemetery.

In the early years of settlement, there was less time for recreation and leisure, and much of that time was spent by the males in one of the local taverns. Late in the nineteenth century, camping and fishing along the Olentangy River were popular, along with visiting such places as Olentangy Park and Glenmary Park by traveling on the interurban.

The Parks and Recreation Department has become a major component of Worthington City Government, and, in addition to the park system spread across the community, there is a Worthington Community Center for indoor activities.

Community theater productions have been quite popular in Worthington and continue to be so. Ironically, the substitute for the local tavern in Worthington has become the Griswold Center, which is designed among other things to serve senior citizens. The new center not only is located in the same general area as the former Griswold Tavern, but it bears the same family name.

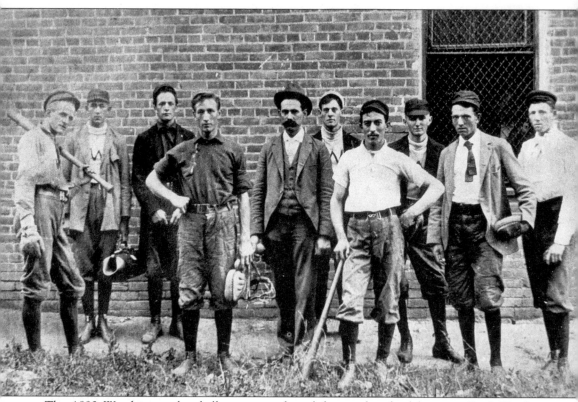

The 1892 Worthington baseball team are, from left to right, third baseman Paul Wright, pitcher Gum Wilcox, left fielder Hen Pingree, catcher Bert Pingree, manager Amos Avery (in jacket), shortstop Hun Tuller, right fielder George Beaver, center fielder Nate Pinney, first baseman Ez Gilbert, and second baseman Otho Noble. They were an interesting group of young men. Fifteen-year-old Nate Pinney was a direct descendant of pioneer Abner Pinney, and 16-year-old Paul Wright was the son of local attorney James E. Wright. Otho Noble would serve in the 4th Ohio Volunteer Infantry in the Spanish-American War, and Hen Pingree would become the Rev. Henry Pingree, who by 1919 was the national superintendent of the Methodist Sunday School Institute in Chicago. (WHS.)

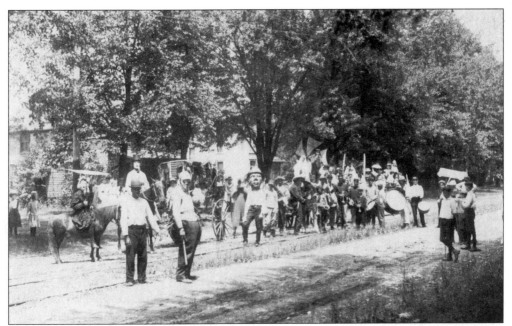

The Fourth of July parade has just disbanded on North Main (now High) Street in the above photograph taken around 1908 to 1910. The tracks and trolley line for the Columbus, Delaware, and Marion interurban line are visible in the picture as are the last three houses on the west side of Main Street, just south of North Street. (WHS.)

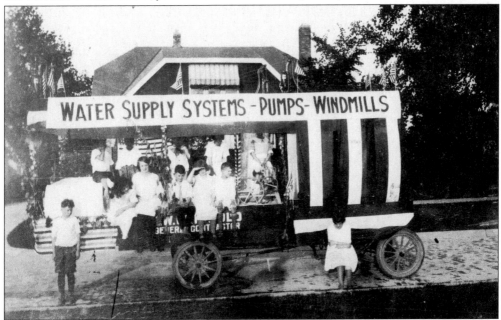

Herbert Griswold's float in the 1920 Fourth of July parade advertises his business, which dealt with water supply systems, especially pumps and windmills for local farmers. This is a 1920 vintage truck, and it appears that this float moves with automotive power; the engine and driver are concealed by the vertical stripes above the wheel on the right side of the picture. (TC.)

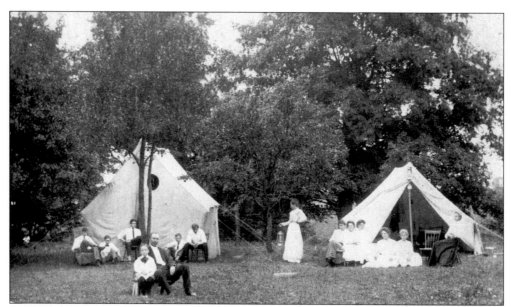

These early twentieth-century tents and campers are pictured at Scatterday's 4-acre orchard on the west side of North High Street just south of Karrington and the Methodist Children's Home. The shirts and ties and summer dresses are rather formal attire for a camp setting, and the plank-bottom chairs and lantern suggest this group brought the comforts of home with them. (WHS.)

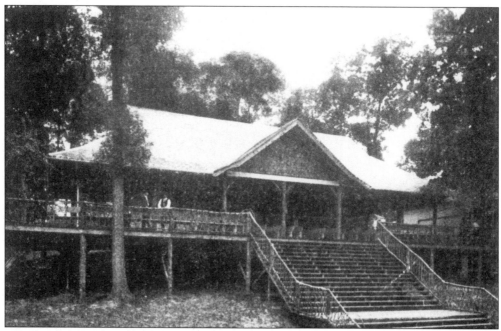

The dance pavilion at Glenmary Park was a major attraction of this park developed by the Columbus, Delaware, and Marion interurban railroad on the east side of present Route 23, just north of the great wooden trestle over the Camp Johnson (Mary Orton) ravine. Like Minerva Park and Olentangy Park, Glenmary was designed to attract interurban passengers to their dance pavilions, playing fields, and picnic areas. (WHS.)

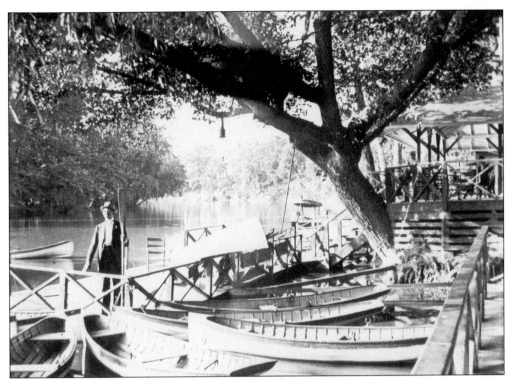

This is the canoe dock at Olentangy Park, where Edwin Viets Griswold, son of W.F. Griswold was employed for the summer at the turn of the century. Olentangy Park—now the site of a residential apartment community along the Olentangy River just north of Arcadia—was older than Glenmary and was designed to encourage travel on the electric street railway. It was a popular site for Worthington Sunday school class picnics. (WHS.)

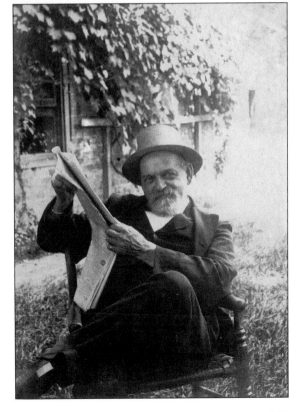

This photograph of Worthington Franklin Griswold enjoying a moment of summer leisure reading the newspaper appears to be posed rather than a candid shot. W.F. was a Worthington businessman and civic leader, and he is sitting in the back yard of his home. It seems that he has adopted the fold used by railroad and subway commuters, perhaps even riders of the CD & M who, unlike Mr. Griswold, commuted daily to Columbus. (TC.)

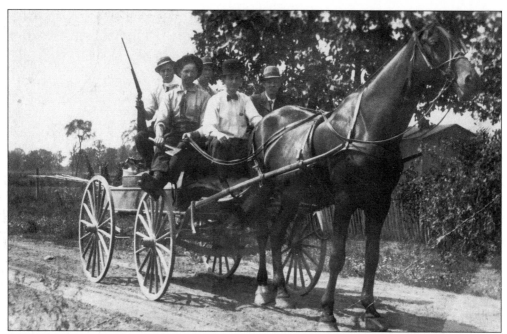

Artie McIlwain, Lester Grace, O.L. Grace, and Bill Bennett were riding with Mr. McIlvanin in this light spring wagon between Worthington and Linworth about 1912. Spring wagons were a common sight along this dirt road that now carries busy Route 161 rush hour traffic. The dressy attire and rifle suggest a sporting event rather than farm labor. (BNG.)

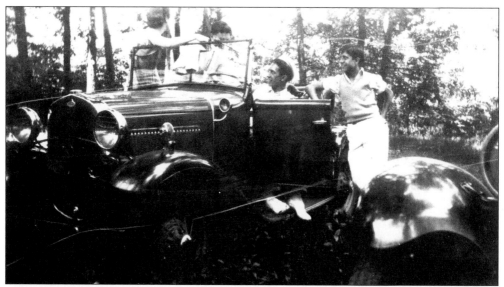

Jack and Bob Fenstermaker, Ruth Dickson, and Bette Norris (taking picture) are exploring a picnic location *c.* 1935 in a highly polished Model A Ford with running boards. Although the men's attire is elegantly casual, a highly polished car and white shoes reflect a rather formal picnic among courting couples rather than the casual arrangements we have come to expect for modern picnics. (BNG.)

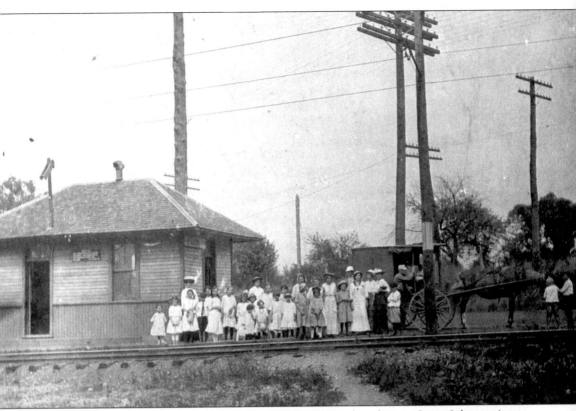

Campers arriving at the Flint railroad station in 1920 wait to be taken to Camp Johnson (now Mary Orton) by horse and carriage. This was a "fresh air" camp operated by the Godman Guild, and many of the children from the heart of Columbus were sons and daughters of immigrants living in the "Flytown" neighborhood on the near north side in the vicinity of West Second Avenue. The train trip itself was undoubtedly an adventure for these children, but the Godman Guild intended the camp "vacation" to offer a contrast to the "perverting influences of the ugly brutal environment of the children in the back streets and alleys" of this neighborhood. Summer tended to be a particularly sickly time with unsafe drinking water and fly-borne diseases. (GG.)

This spring wagon drawn by "Faithful Bill" provided the last stage of the journey to Camp Johnson, and the smiling faces of these inner-city children suggest that they were arriving for an eagerly anticipated adventure. (GG.)

Tents and teepees comprised the Camp Johnson facilities in 1914. The camp began when Annetta Johnson St. Gaudens gave 11 acres of her family farm to the Godman Guild to provide a healthy vacation experience for inner-city youth. In 1925 the Guild purchased 125 adjacent acres for expansion and renamed the property Camp Mary Orton, for an influential trustee. (GG.)

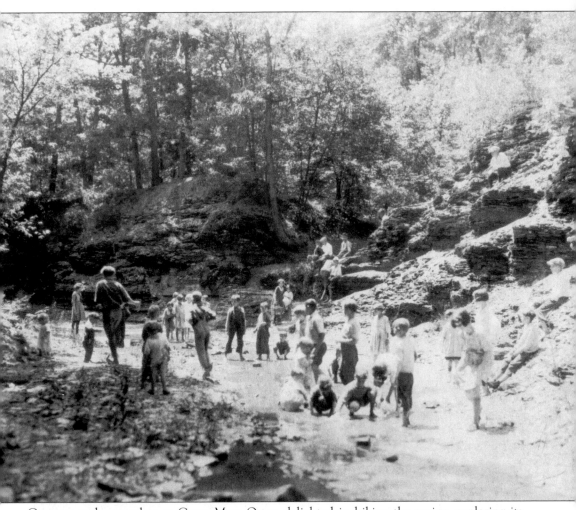

Campers and counselors at Camp Mary Orton delighted in hiking the ravine, exploring its geology and natural beauty. The camp and the ravine still exist in much the same condition as shown in the above photograph from the 1920s. It is a highly treasured piece of the Worthington area's natural landscape. (GG.)

The Pioneer Movie Theater opened September 22, 1928, in the remodeled Wing Garage, west of High Street behind the hardware store. It contained 500 seats, a stage for dramatic plays, and a $4,000 organ. Admission was 25¢ for adults and 15¢ for children. The building still stands but the canopy in the picture has been removed, and movies long ago moved to multi-screen complexes with stereophonic sound. (PS.)

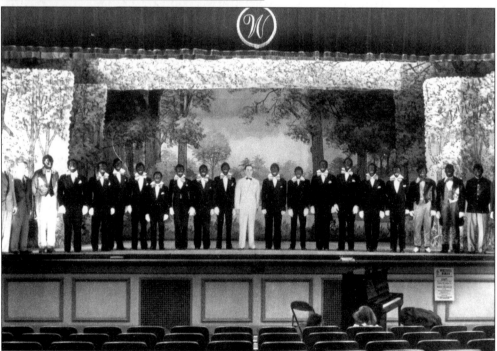

Cast members of this *Minstrel Show* in the current Kilbourne Middle School auditorium in 1943 wore "black face" and no doubt engaged in humor that would be completely unacceptable in the Worthington community today. The show was undoubtedly planned as a diversion from the anxieties of World War II, and the school auditorium at that time had the only stage in the community suitable for theatrical productions. (WHS.)

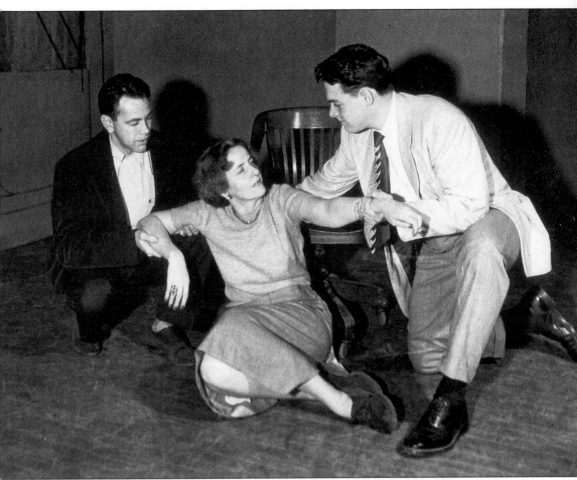

Hugh Flaherty, Deborah McKibben, and Jack Barber are seen here in the Worthington Players Club production of the three-act mystery-comedy, *Ghost Train*, February 17 and 18, 1950. The play was directed by Harry Luck, and other cast members were Fritz Kennard, Vera Spring, Barbara Boyd, Robert Kern, Frank Welling, Robert J. Kreiger, Floyd Linn, and Don Moore. In the post-war era Worthington was too small to attract traveling theatrical or musical companies and had no community facility with appropriate stage equipment for such troupes, but amateur community theater flourished before appreciative local audiences in the school auditorium. (H&SF.)

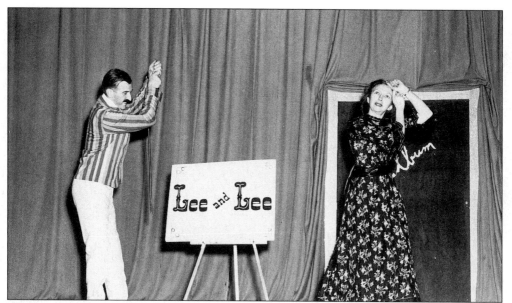

Charles and Janet Lee performed *The Curfew Shall Not Ring Tonight* in the Worthington Women's Club Gay Nineties Revue held on January 15, 1949. It was a gala affair offering musical renditions such as *A Bird in the Gilded Cage*, *Merry Oldsmobile*, and *Comin Thru the Rye*. (CL.)

This Halloween celebration just after World War II features James Talady, the Worthington marshall, as the arresting officer, and Warren Insley, editor of the *Worthington News*, portraying the role of Adolph Hitler. The subject seems a bit macabre for children and ironic for Insley, who served as an infantry first sergeant in Europe and was wounded during World War II. (WHS.)

An extensive collection of muskets and rifles, as well as bows and arrows, were required for the militia sequences in *The Whetstone Adventure*, a sesquicentennial pageant written and directed by Frank Corbin that required the efforts of hundreds of citizens as performers and assistants. It was presented on Monday, Wednesday, and Saturday nights at the ball fields at the corner of Stafford Avenue and Morning Street and was certainly the highlight of that week designed to acquaint area residents with the heritage of their community. The Sesquicentennial celebration attempted to involve every group and individual in the community, from Armed Services Day on Monday, to a musical program by the Worthington Women's Club, a "Fraternal Orders Day" on Wednesday, and a homecoming address on Saturday. (HZ.)

This banner across High Street proudly proclaims the Worthington Sesquicentennial celebration the week of October 5–11, 1953. The celebration began with a parade down High Street October 5, but there were so many activities throughout the week that a special information booth was set up on the northwest quadrant of the Village Green; it can be seen on the left side of the above photograph. (WHS.)

Displaying the nickname of President-elect Eisenhower on the village water tower in Worthington in 1952 may have resulted from part of the campaign effort. It was also very likely part of the spirit of celebration. (WHS.)

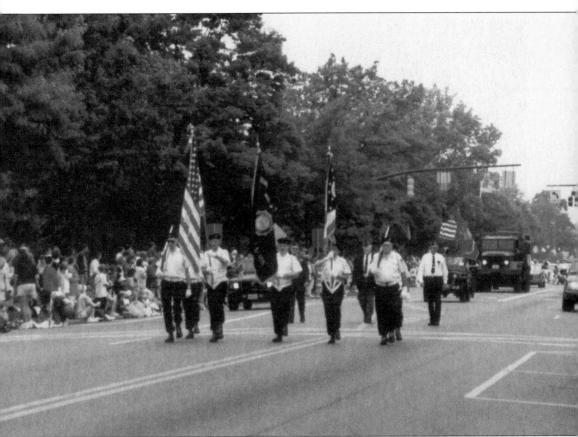

The color guard from the Leasure-Blackston American Legion Post leads the Memorial Day parade that the group organizes each year. Beginning at Sharon Memorial Hall, the parade marches west on Granville Road to High Street and then south to the entrance of Walnut Grove Cemetery. Worthington's parade is the largest in central Ohio and has been featured on television as one of the outstanding community Memorial Day parades in the country. Organizations such as the high school marching bands, fire department vehicles, and scout troops compete for attention with antique car clubs, public officials campaigning for election, rifle companies of Civil War re-enactors, baton twirlers, and precision flag corps. Worthington's Memorial Day parade invites everyone to join in remembering those who served their country and has become a family tradition—grandparents and grandchildren equally delighted by the spectacle. (VEM.)

The high school girls' chorus is participating in the ceremonies at Walnut Grove Cemetery, which annually concluded the city's Memorial Day celebration with a speaker and a military salute. Walnut Grove was established as the community cemetery in the mid-nineteenth century tradition of "lawn" cemeteries, with the first burial taking place in January 1859. (CW.)

The El Rancho Polo team was a popular summer attraction for Worthington residents in the late 1950s and early 1960s. The four-member team piloted by Walter Shapter, a nationally recognized polo veteran, played its games on Sunday afternoons at their field on the north side of East Granville Road, in what is now the commercial area bisected by Busch Boulevard. (WACC.)

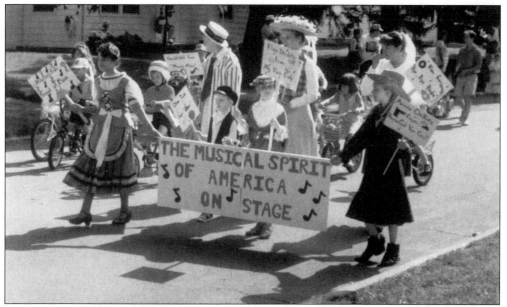

The "kiddie parade," followed by a morning of games and contests for children, was an important part of the Colonial Hills Civic Association Fourth of July celebration, which has been a tradition each year since 1945. It begins in patriotic fashion with the flag raising by the American Legion post, and proceeds from the entire family-fun event are used for neighborhood projects. (CW.)

Here we see Nicky and Chris McCormick preparing their vehicles for the 1955 "kiddie parade." All bicycles, tricycles, or scooters were appropriately decorated with crepe paper and flags. The much awaited final event each year was the fireworks display, which has now been moved to the Thomas Worthington High School stadium as a city rather than a neighborhood event. (RWM.)

The "Folklife Festival," sponsored each summer by the Worthington Arts Council, includes displays of varied arts and crafts on all four quadrants of the Village Green. Each year's festival has a different theme, but concerts of folk melodies featuring traditional instruments such as banjos and dulcimers are guaranteed to draw and hold an appreciative audience. (WAC.)

Old Worthington Market Days each September overflows the Village Green, and High Street is closed to traffic from there to South Street for booths offering a wide variety of foods, dried flowers and wreaths, art and craft items, and information about Worthington organizations. The Worthington Historical Society flea market is traditionally on the southeast quadrant, the Friends of the Library book sale on the northeast, and the Senior Center pancake breakfast on the northwest. (RWM.)

A 120-by-50-foot swimming pool with a diving bay, bathhouse, and refreshment stand was completed in the 1950s at a cost of $180,000 by Swiminc, Inc., a subsidiary of the Worthington School District Cardinal Boosters, who raised the funds by selling non-interest-bearing bonds. This pool on the campus of Thomas Worthington High School continues to be used by families throughout the school district. (WACC.)

The ice rink created above at the Worthington Estates School playground was a safe and popular alternative to the Olentangy River when weather conditions permitted it. This cooperative venture of the Worthington Parks and Recreation and Fire Departments involved spraying water on the playground and has been done in various locations over the years when the weather remained below freezing. (CW.)

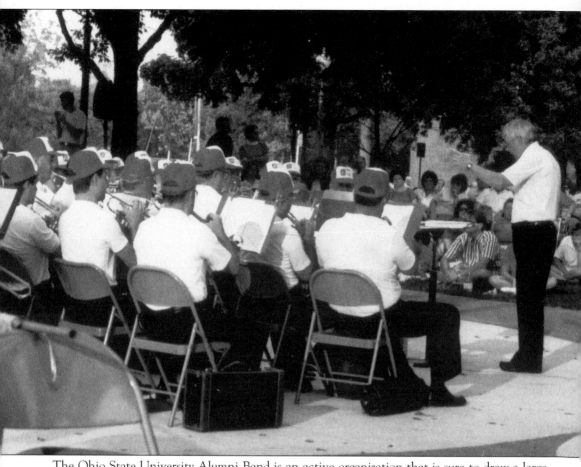

The Ohio State University Alumni Band is an active organization that is sure to draw a large audience when it performs during the weekly Sunday evening concert series on the Village Green. Sponsored by the Worthington Parks and Recreation Department at a special stage area on the northwest quadrant of the Village Green, the summer concerts featuring different musical groups each week are very popular with local residents. Crowds on the Village Green for public events have been popular ever since the first Fourth of July celebration in 1804. Diverse activities continue today with school children picnicking there during "Third Grade Week," craftspeople displaying their wares during the Folklife Festival, concerts like the one above throughout the summer, the Worthington Historical Society ice-cream social, and the annual lighting of the community Christmas tree sponsored by downtown merchants. (CW.)